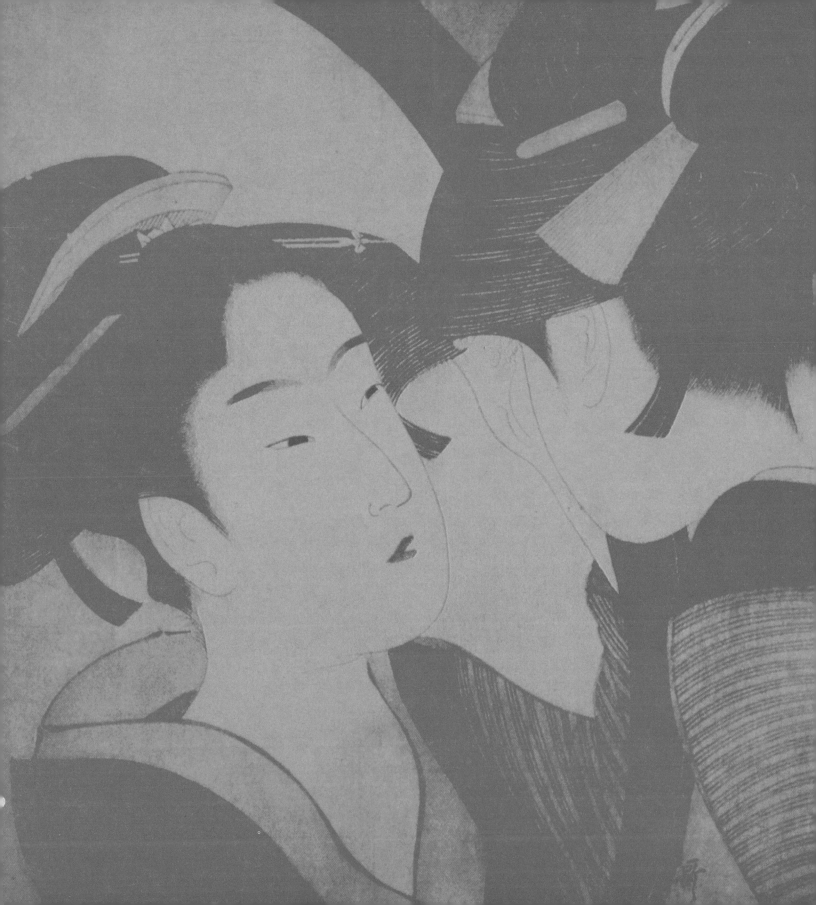

LAUREL GLEN PUBLISHING

THE ART OF JAPANESE PRINTS

NIGEL CAWTHORNE

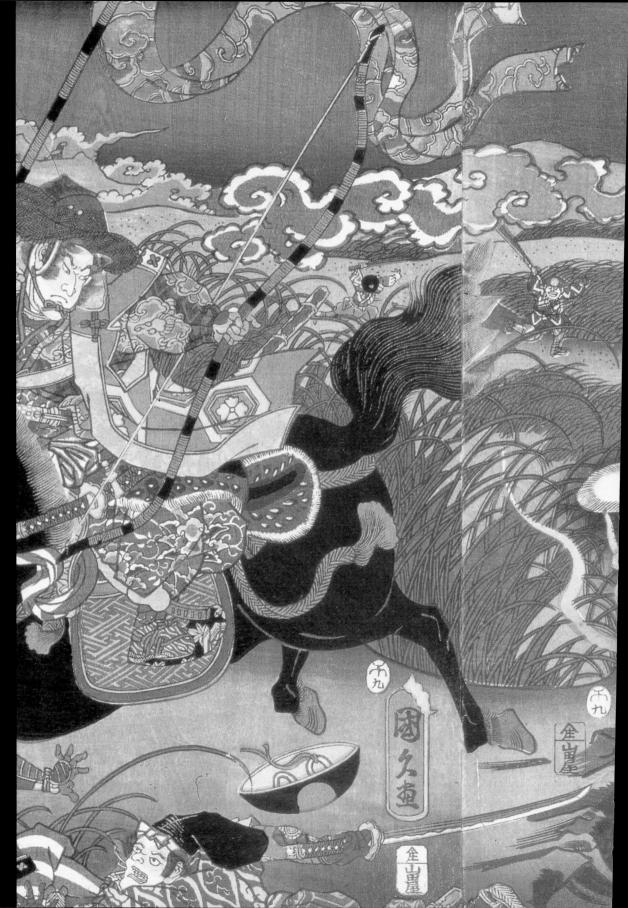

Published in the United States by Laurel Glen Publishing, 1997
Laurel Glen Publishing 5880 Oberlin Drive Suite 400, San Diego, CA 9212

First published in 1997 by Hamlyn, an imprint of Reed Consumer Books Limited, Michelin House, 81 Fulham Road, London SW3 6RB and Auckland, Melbourne, Singapore and Toronto

Printed and bound in Hong Kong

Library Of Congress Cataloging-in-Publication Data available upon request.

Publishing Director: Laura Bamford
Executive Editor: Mike Evans
Assistant Editor: Humaira Husain
Art Director: Keith Martin
Design: Geoff Borin
Production Controller: Mark Walker
Picture Research: Charlotte Deane

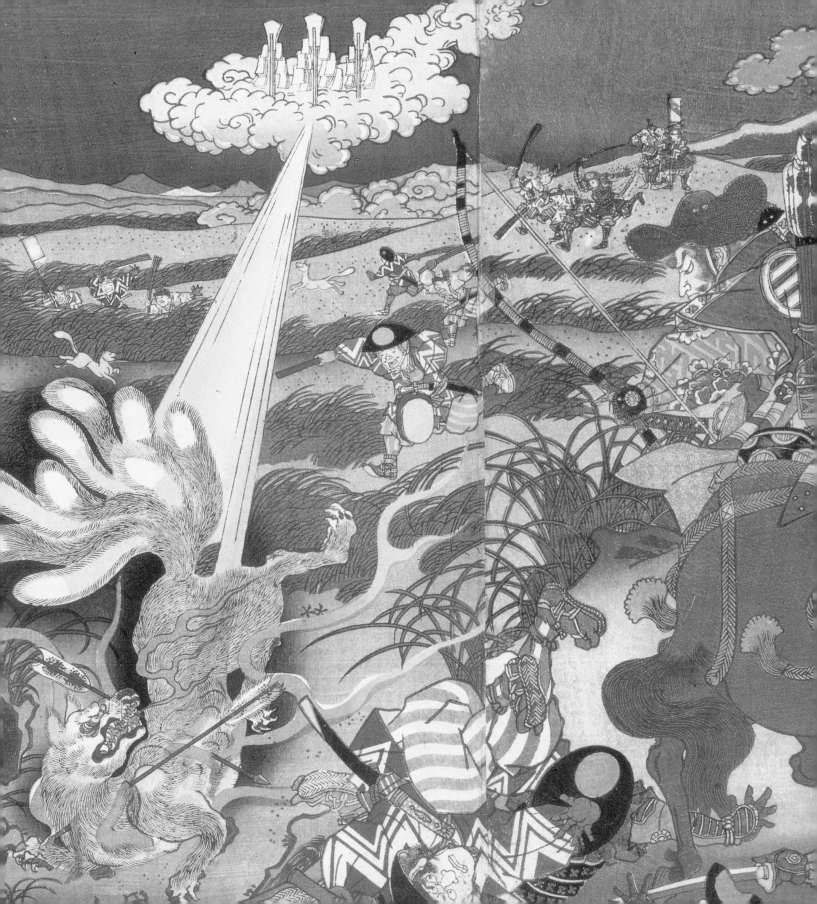

1

The History of the Japanese Print

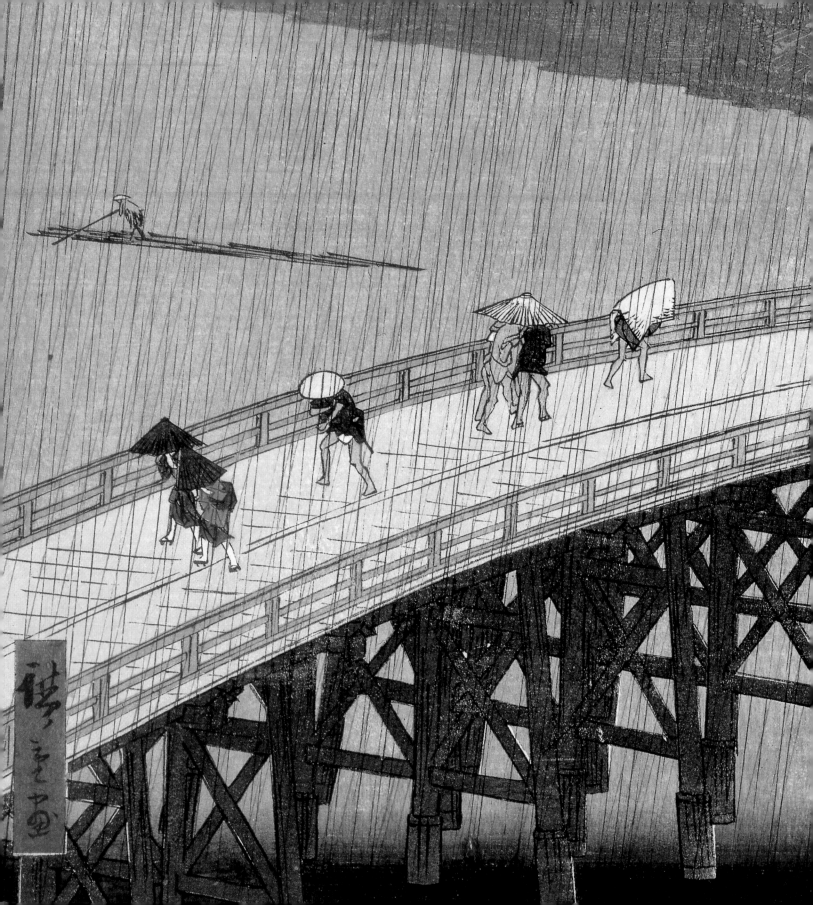

Although printing almost certainly began in China, the earliest existing examples are Japanese. In A.D. 764, the Japanese empress Shotoku decreed that one million miniature pagodas should be made. Each was to contain a Buddhist charm on a slip of paper. To speed up production, instead of writing out the charms, they were printed.

Buddhist texts appeared in Japanese from around 1088, after the early Buddhist canon, known as the *Three Baskets*, was imported from China. Around a hundred years later, woodblock decorations were added.

By the twelfth century, Japanese monks had taken to repeating the name of Buddha as a way to reach enlightenment. One easy way to do this was to print it out using a woodblock. These images soon became elaborate as the monks perfected the skills of block-making and printing.

Soon Buddhist texts were printed with grand and lavish frontispieces, produced in a Chinese style. But by the fifteenth century a distinctly Japanese style had developed.

Printing had been confined to temples and monasteries until the end of the sixteenth century, when the civil war that had lasted for most of the middle ages solidified into uneasy peace. In this more settled atmosphere, the arts started to flourish. The feudal war lords—the samurai—built themselves castles to consolidate their fiefdoms. They employed artists and craftsmen to decorate their new homes. The merchants of Kyoto and Sakai, who had largely financed the wars, also had more money to spend. They did not pretend to be aristocrats, and commissioned paintings which showed pretty courtesans—which was the beginning of what became known as *ukiyo-e*.

Then, in 1603, the Shogun—or military dictator—Leyasu Tokugawa moved his headquarters to Edo. Edo became the administrative center of the country, but the old imperial capital—Kyoto—remained home to the powerless imperial court. It was only in 1868, when the Emperor Meiji took political power in Edo, that Edo officially became the capital of Japan and changed its name to Tokyo.

The 255 years of the Tokugawa shogunate—known as the Edo period was marked by the growth of Edo as a great political, administrative, and commercial center. This rapid growth gave Edo a flourishing middle-class society who were rapidly cut off from the traditional Japanese arts, which remained based in Kyoto.

◀ **Utagawa Hiroshige (1797-1858)**
Sudden Shower at Ohashi Bridge at Ataka, from the series "100 Views of Edo"

Besides, the new middle class wanted arts reflecting the down-to-earth life of the common people, rather than the courtly life of a time gone by. The traditional *Noh* theater had become the exclusive province of the upper classes, while the merchants enjoyed the new *Kabuki* dances.

Kabuku simply meant "fashionable." Initially *Kabuki* troupes consisted of men dressed as women and women dressed as men. But many of the women dancers supplemented their earnings by selling their sexual favors. The authorities cracked down. To prevent *Kabuki* being merely a front for prostitution, the women's parts were taken over by young boys. This though, produced similar problems and eventually mature men ended up taking all the parts.

The wives and daughters of the merchants flocked to the *Kabuki*, and the lucky ones took actors as their lovers. *Kabuki* did also have a male following, but most men found their entertainment in brothels. They were not just a place for extramarital sex, but the center for relaxation and entertainment of all kinds. Rich merchants spent much of their time there, as they were treated better than samurai—provided they had the money to pay for their pleasure. Sex was on sale, of course, but it was always hidden under a rich, cultured, and seductive veneer.

This demimonde was originally described by the Buddhists as the *ukiyo*—the sad world. But in the middle of the seventeenth century the character for *uki* changed its meaning from "sad" to "floating," so *ukiyo* came to mean the floating world—a world full of transitory pleasure and freedom from care. The word for pictures in Japanese is *e,* and paintings or prints of the floating world are called *ukiyo-e.*

With the increasing wealth of the merchant class, there was a great explosion of secular books and printing. The first Japanese illustrated books appeared around 1650. The early ones were simple scrolls and the increasingly lavish illustrations were hand-painted. But soon books were printed and bound. Woodblocks were used to create the illustrations, so they could be printed alongside the text in a single process.

Initially, the pictures were crude and subordinate to the text. But soon they began to dominate and were accompanied by easy-to-read syllabic *kana* characters, rather than the formal Chinese *kanji* characters used in classical literature. These books were so heavily illustrated that they even sold to the illiterate.

▲ **Anchi Kaigetsudo (1671-1743)**
Standing Courtesan

▶ **Utagawa Kunisada (1786-1864)**
Moronao, the villain of the Kabuki play *Chushingura* (1852)

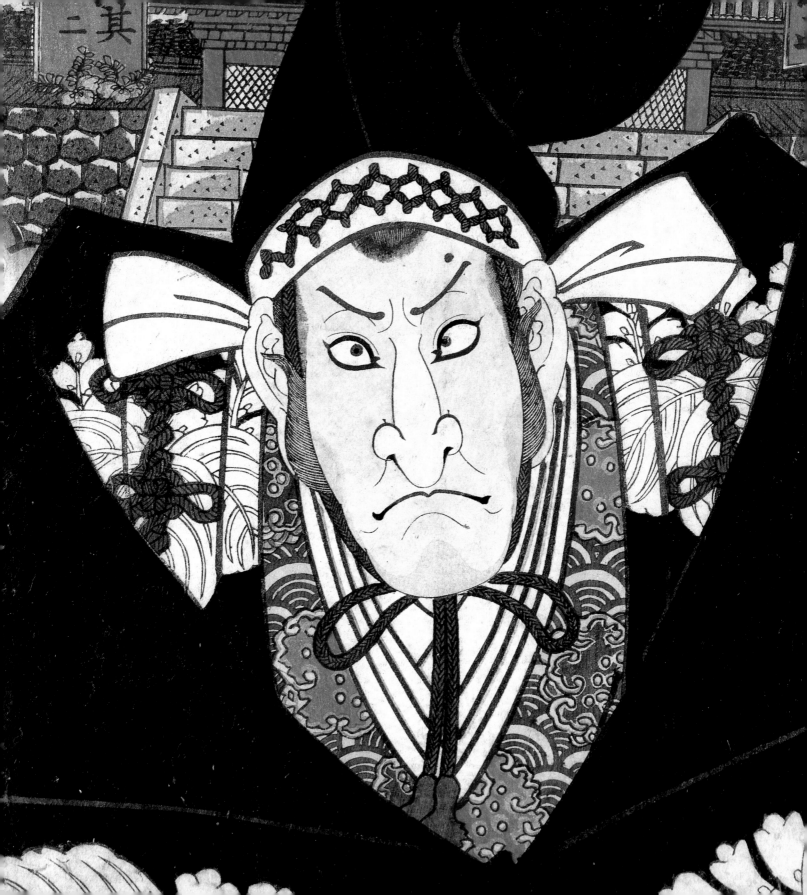

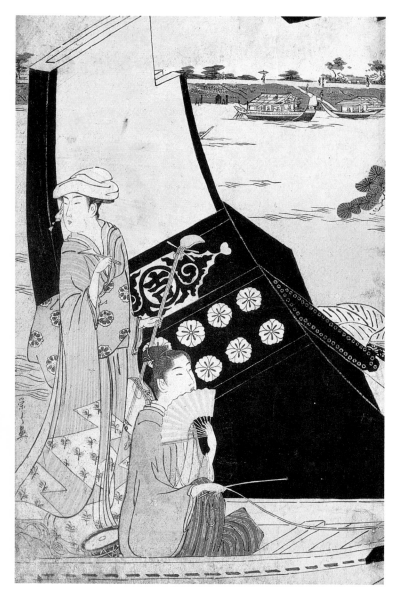

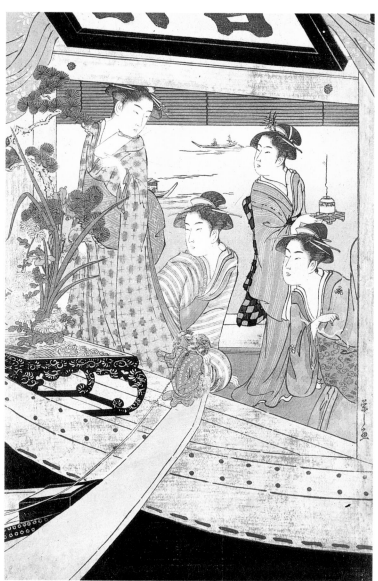

▲ **Hishikawa Moronobu (1618-1694)**

Party on a Riverboat

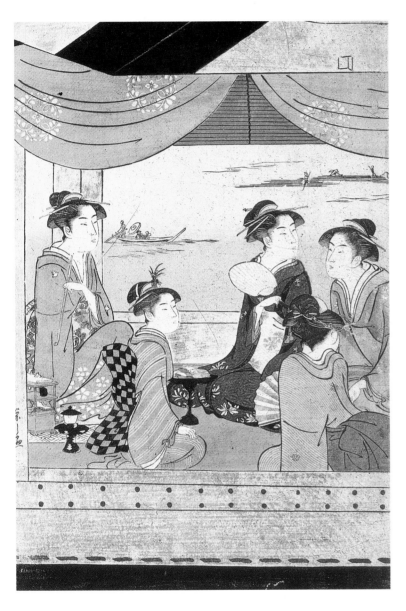

Many of them were highly explicit sex manuals. Some of the pictures, called *shunga* or spring pictures, were highly erotic, with figures' genitals exaggerated to an almost ludicrous degree. Despite regular periods of repression, this *shunga* tradition continued throughout the Edo period when Japanese prints were made.

Other popular books were guides to the famous courtesans of the day, with portraits and verse eulogies to the girls' beauty and talents. But their faults were also detailed, along with their address and price. One of the earliest and finest of these *ukiyo-e* books was the *Yoshiwara-makura* or Yoshiwara Pillow. It had forty-eight pages showing the famous courtesans in intimate positions with their lovers—traditionally in Japan there are forty-eight sexual positions.

In 1657, a great fire virtually destroyed all of Edo. In the aftermath of the catastrophe, people struggled to rebuild their homes and there was a ready market for cheap decoration. In 1660, spotting this possible gap in the market, Hishikawa Moronobu, an illustrator who was working under contract in Edo, persuaded his publishers to sell his work as separate sheets with no text.

The prints could be bought from the publishers' stores or from street vendors, and they could be pasted on walls or screens to brighten up a new home. Prices varied, depending on the quality and size. But up until the mid-nineteenth century a print could be bought for the same price as a bowl of noodles—a regular meal for most people.

Moronobu was plainly aware of the significance of his work. Later, he signed them *Yamato esti*—which means master of Japanese painting. His work sold well and others soon began to follow his example.

The works of Moronobu and his contemporaries that appeared in the mid-seventeenth century were the first of what we today think of as Japanese prints. They featured the key elements of *ukiyo-e*, that is sexual activity, courtesans, and the *Kabuki*.

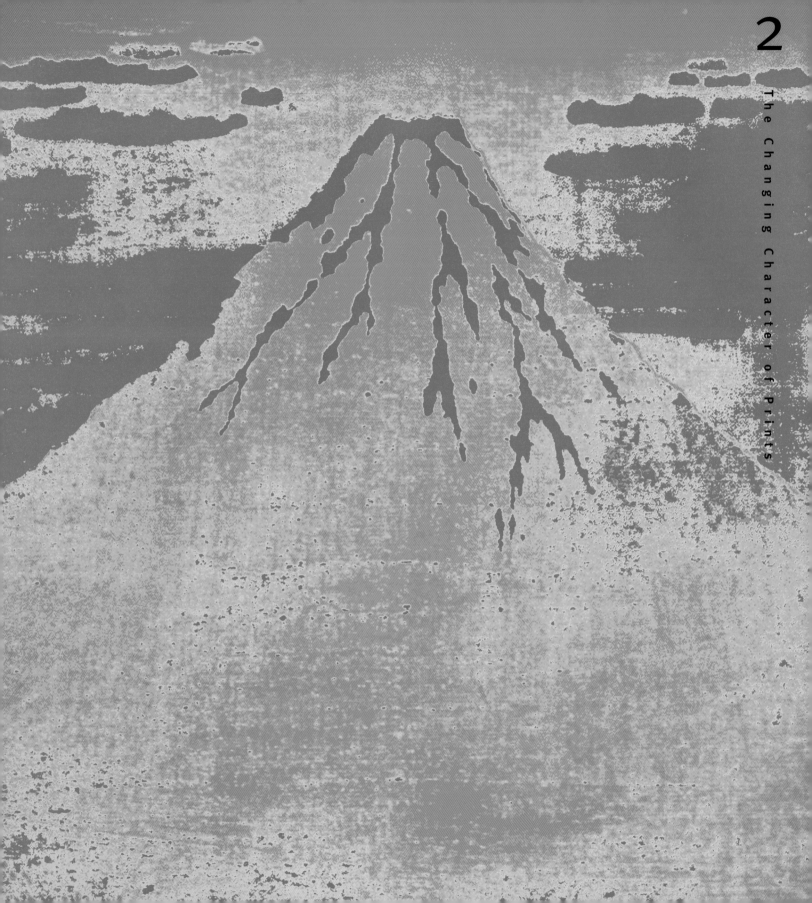

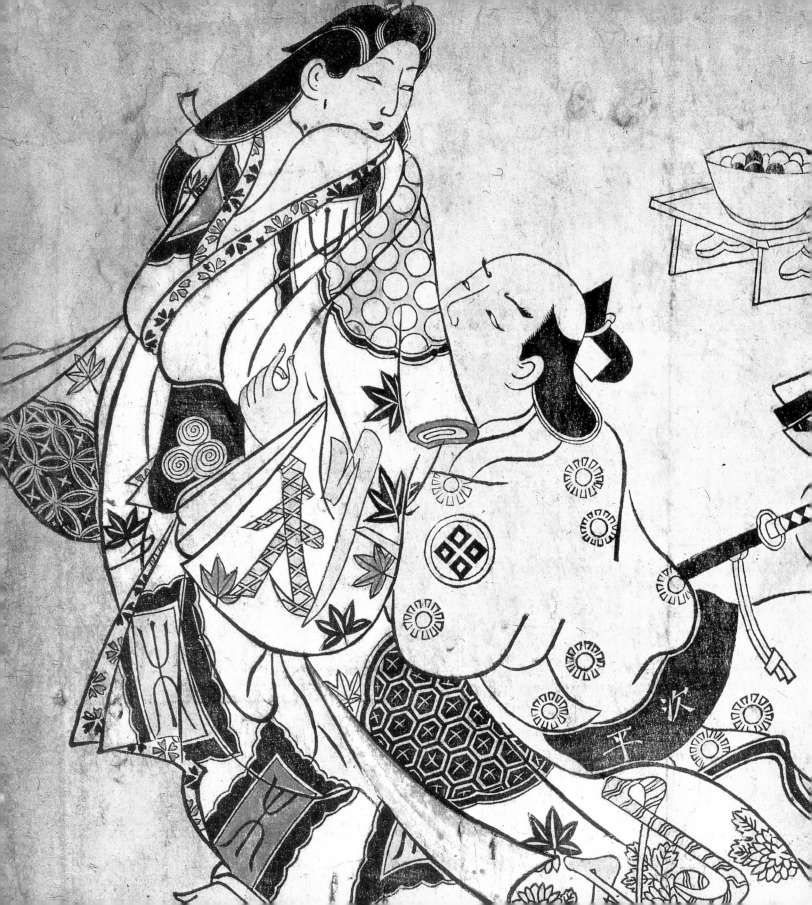

Early prints were printed black on white, but print buyers were soon demanding color. The oranges and greens were often applied by hand and usually in bold brush strokes by skilled artists. Unfortunately, the pigments they used were mineral, which deteriorated with age. The orange—which is red lead—became bluish-black and the mineral green darkened and sometimes ate through the paper.

Since the early 1600s, color printing had been used in mathematical diagrams. This soon spread to commemorative prints and illustrations for printed works of the *haiku* poetry society. But it was a laborious process, which made it too expensive for cheap published prints. The style often aped Chinese prints. Limited editions were printed and they were bought only by a few connoisseurs.

In the Kyoho era (1716-1736), the government tried to impose austere Confucianism on every aspect of Japanese life and very soon these deluxe publications were banned. The government restricted the size of prints and colors used. *Shunga* pictures were outlawed altogether, on the grounds that they were a threat to public morality. Also outlawed were prints that depicted current events or sought to show the shogunate in a bad light. Punishments ranged from jail to exile and confiscation of property.

At the same time though, the Kyoho reforms lifted the ban on foreign books—with the exception of works on Christianity. The aim was to encourage scholarship, and Japan started to import illustrated books from China and the West. The effect could soon be seen in Japanese prints and the pioneer Okumura Masanobu soon began to use the Western idea of perspective in his prints.

In the 1740s, color made a comeback. Red and green were added to published prints, using extra woodblocks. Three- and four-color printing began in the 1750s. Then, in 1764, a number of art lovers decided to get together and produce an illustrated calendar for 1765. They commissioned a relatively unknown artist called Suzuki Harunobu, who produced the first mass-market full-color prints. The key to the process was a registration system, which used notches carved in the sides of the wooden printing blocks. This made alignment of the blocks, and hence the colors, quick and easy for the first time.

Harunobu's style was distinctly Japanese. His prints were soon sold separately, launching a popular fashion for full-color prints. Prints using a

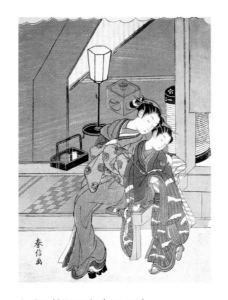

▲ **Suzuki Harunobu (1725-1770)**
Courtesan with Her Attendant

◀ **Sugimura Jihei (active 1680-1698)**
The Insistent Lover

The Changing Character of Prints

dozen colors or more were produced. The prints were known as *Azuma nishiki-e*—Eastern brocade pictures. They were considered the eastern equivalent of the colorful brocades of Kyoto, which lay to the west.

In the Kansei era (1789-1801), another attempt was made to clamp down on the publishing industry. The artists and writers of Edo's "floating world" came under particular attack. The publisher Tsuta-ya Juzaburo, who was popularly known as Tsutaju, was fined so heavily that he had to close his shop. Writer and artist Kyoden Masanobu was shackled and spent fifty days under house arrest and Utamaro—the leading printmaker of the early nineteenth century—was jailed for making a series of prints which satirized figures from the sixteenth century. These were the very men who had established the shogunate.

This attack led writers and printmakers to change their tack. Some left publishing altogether. Some devised secret codes to fool the censors, while others moved on to safer subjects.

Fortunately, there were safe subjects. During the first decade of the nineteenth century, there had been something of a boom in the tourist trade. Printmakers began to move out to the outskirts of town on the main thoroughfares where they sold souvenir prints to travelers. These prints depicted landmarks in and around the city. Famous or scenic places are called *meisho*, so these pictures were known as *meisho-e*.

These souvenir prints led to an explosion of interest in landscapes. Katsushika Hokusai made himself a legend overnight with his "Thirty-six Views of Mount Fuji." There were actually forty-six views of Mount Fuji. The volcano had not erupted since 1707 and was around a hundred miles from Edo. But it was an object of veneration. Male pilgrims from all over Japan scaled the sacred mountain every summer and it was Hokusai who made Mount Fuji central to the identity of Edo and, later, to Japan itself.

The printmakers who followed in Hosukai's wake were also helped by his *Manga*, a series of sourcebooks for beginners. In them, he sketched every conceivable subject.

Hokusai was followed by Hiroshige, who was samurai and familiar with many styles of painting. He traveled widely around Japan. He brought an emotional dimension to his landscapes. This struck a nostalgic chord in city dwellers who were beginning to feel themselves cut off from their roots in the countryside.

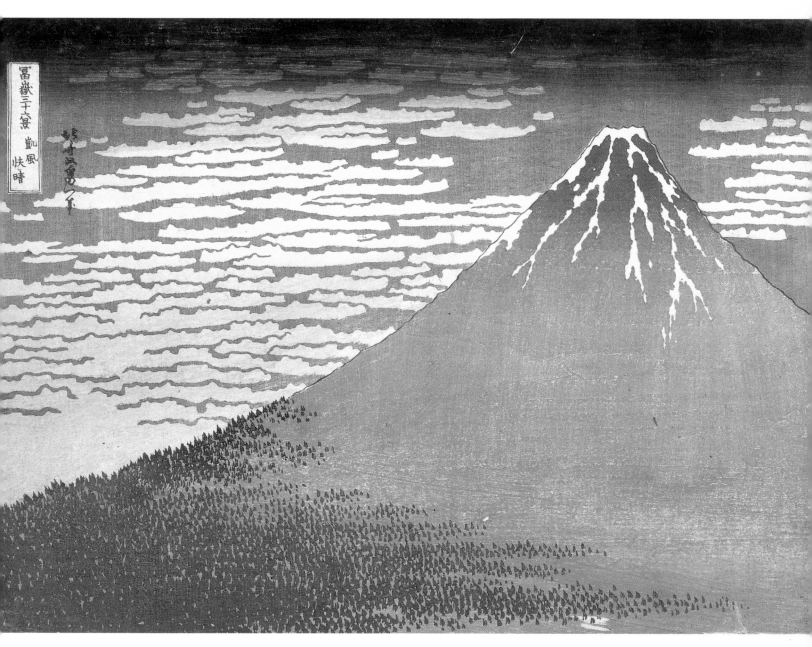

▲ **Katsushika Hokusai (1760-1849)**

Fuji in Clear Weather, from the series "36 Views of Mount Fuji" (1823-29)

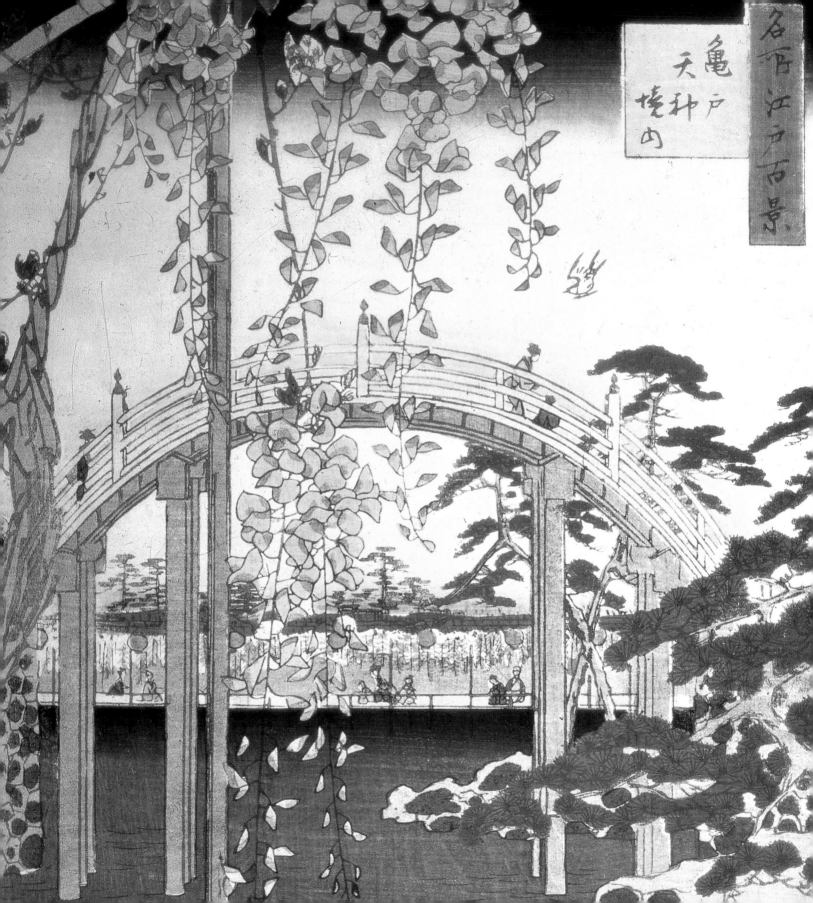

名所江戸百景

亀戸天神境内

Japan was almost completely closed to foreign trade throughout the Tokugawa period. However, in 1853, it was forcibly opened by an American gunboat. The first Japanese art to be seen, or appreciated, in the West were the famous landscape prints of this period. Even today probably the two Japanese prints best known in the West are Hokusai's "Fuji in Clear Weather" and "Great Wave off Kanagawa."

At that same time, Hiroshige turned his attention to depicting scenes in the city. In answer to Hokusai's "Thirty-six Views of Mount Fuji," Hiroshige produced his "One Hundred Famous Views of Edo." By using the tradition of the *meisho-e*, for the first time, these prints brought, in vivid color, a view of Japan to the outside world.

Contact with the West was, however, the beginning of the end for the traditional Japanese print. People were soon more interested in absorbing the new science and technology coming from the West, than preserving the traditional arts. Quite simply, the print could not compete with the onslaught of photography.

However, a few gifted and determined individuals struggled to keep the work alive. Yoshitoshi began to issue "color supplements" for some of the

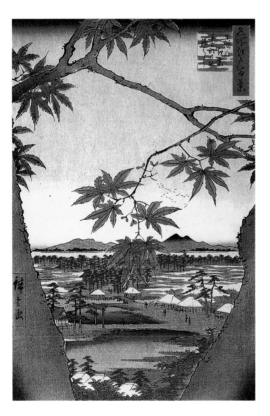

◀ **Utagawa Hiroshige (1797-1858)**
Maples at Mama, from the series "100 Views of Famous Places in Edo"

◀ **Utagawa Hiroshige**
Wisteria in Full Bloom, from the series "100 Views of Famous Places in Edo"

The Changing Character of Prints

popular newspapers. His broadsheet prints sold out on publication until, shortly before his death in 1892, he went insane.

Other printmakers—such as Kiyochika and his followers—attempted to incorporate elements from European realism and photography. The Japanese print had one last flourish—as propaganda.

During the Sino-Japanese War of 1894-5 and the Russo-Japanese War of 1904-5, print artists turned their hand to depicting the triumphs on the battlefield. Long schooled in turning out advertising prints for the *Kabuki*, they could get pictures of the latest victory – or defeat – out on the streets quickly. *Senso-e*, or war pictures, were usually produced as triptychs. But this function was soon overtaken by photography.

Contemporary Japanese prints had abandoned warlike themes and have been heavily influenced by Western artistic movements—particularly Dada and Surrealism. Although new Western techniques like photogravure are used, most exponents of print-making in Japan employ traditional wood-block methods, arguing that it is a uniquely Japanese medium of expression whatever the subject matter.

During the 1920s and 1930s, the publisher Watanbe encouraged new printmakers, and this led to the creation of a neo-*ukiyo-e* style, which depicted pretty girls in mildly erotic settings. Meanwhile, Hasui and Hiroshi Yoshida have continued the tradition of landscapes.

▶ **Tsukioka Koyko**
The Russo-Japanese War, 1904-5

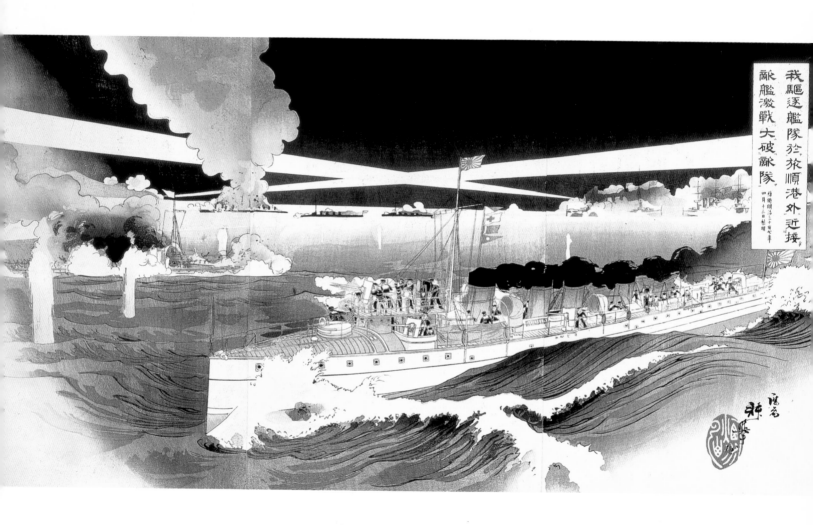

我驅逐艦隊於旅順港外近接敵艦激戰大破敵隊

The use of woodcuts came naturally to the *ukiyo-e* artists. There was a long tradition of woodcut-engravers in Japan. They produced books and were trained to cut blocks, accurately copied from brush-drawn Chinese or Japanese characters. That skill was easily transferred to the production of wood-block illustrations, as the block-cutter could translate the artists' drawings into wood with a high degree of fidelity. So it was natural that the first prints appear as black-and-white illustrations in books.

When the prints were sold as separate sheets, they were made larger than the normal book illustrations. These broadsheet *ichimai-e* were often placed in a quiet room, and contemplated in peace, like the *tokonoma* paintings in upper-class houses. To more closely imitate paintings, color was added by hand, but the black design of the woodcut remained the dominant feature. Later a lustrous black was added and brass and other metal dusts were applied to ape the gold used in Japanese lacquerware.

Although Chinese methods of color printing were known early on, they were too expensive to apply to *ukiyo-e*. Japanese printmaking was largely a commercial enterprise, which aimed mainly to produce cheap household decoration for ordinary people.

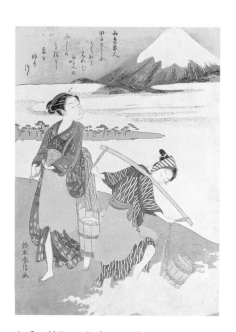

▲ **Suzuki Horunobu (1725-1770)**
Salt Maidens on the Tago-no-ura Beach with Mount Fuji Behind

▶ **Torii Kiyonaga (1752-1815)**
Cherry Blossoms at Asakayara Near Edo (1777-78)

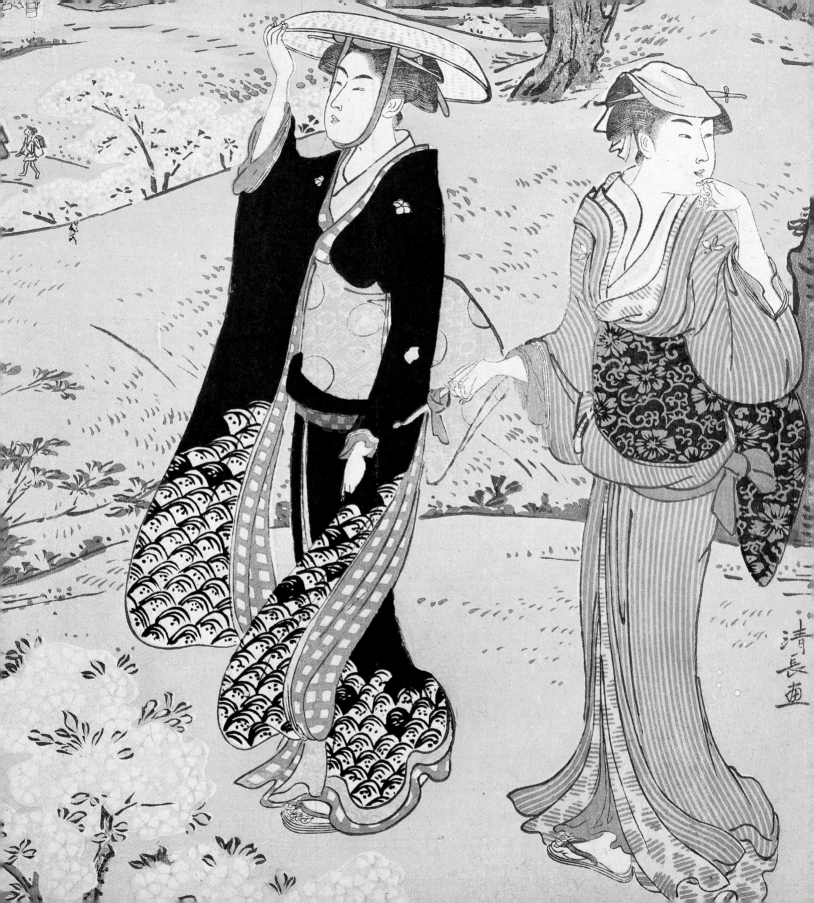

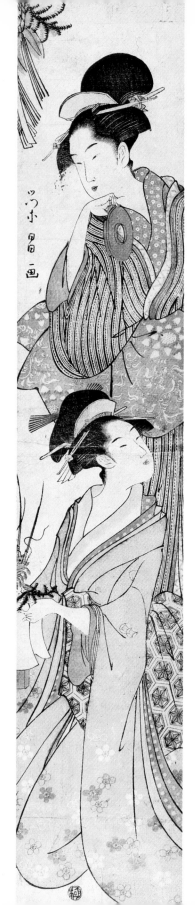

But when cheap red and green vegetable dyes became easily available, artists and printmakers began to use them by printing them from an extra block. However, the new colors were considered garish. In order to try and compensate, the prints became smaller, figures more slender, and any decorative motifs less robust.

Suzuki Harunobu is the man credited with the development of the full-color or polychrome print. But print production was a collaborative effort. The publisher played an important role. He conceived and commissioned the work, financed its production, and coordinated the efforts of those involved. He was also ultimately responsible for its sale and distribution.

The artist was employed to design the print. A separate calligrapher was sometimes used too, if words were to accompany the illustration. Then there would be a block-maker and a printer.

Another key contributor was the papermaker. The wonderful texture and rich surface of the handmade, mulberry-bark papers enriched the bloom and radiance of the printer's colors.

The artist would supply his design as a line drawing in ink, with a wash or symbols to indicate the colors. A pupil or an employee of the printer or

◄ **Chokosai Eisho (active 1790-1799)**
Two Girls on New Year's Day

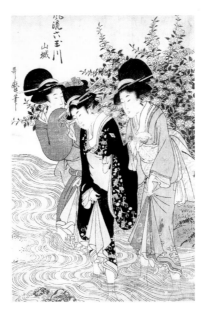

▲ **Kitagawa Utamaro (1753-1806)**
Yamashiro Province: Girls Paddling in River (c. 1790)

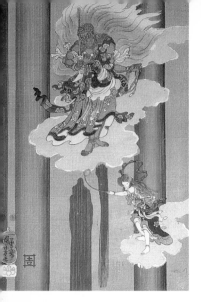

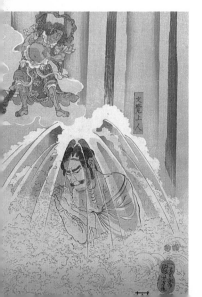

publisher would make a copy on thin, transparent paper. This was known as the *hanshita-e*. Once the colors had been finalized, the publisher would then buy a number of thick hardwood blocks. With color printing, seasoned cherry was used. These blocks were expensive so, to cut costs, both sides were used. So if ten colors were printed, just five blocks were required. And sometimes, to save money, old blocks were planed down, recarved and reused.

The block-maker would then paste the *hanshita-e* face down on to one of the blocks. The blocks were then cut with the grain and the drawing was laid on to the smooth "plank" of the block—in Western printing the "end-grain" is used.

The *hanshita-e* was usually cut up in this process, although some have been found still intact. This suggests that, in some cases at least, the block-maker worked from a copy.

The block-maker would cut around the lines with a knife. Then he would clear the wood in between, leaving the lines in high relief. The remaining paper was washed away leaving the "key-block" ready for use. Ink was rubbed on the raised lines and proofing paper was placed over

◀ **Utagawa Kuniyoshi (1797-1861)**
Mongaku Shonin Under the Waterfall (c. 1851)

▶ **Utagawa Kuniyoshi**
Mongaku Shonin Under the Waterfall, bottom panel detail of the vertical triptych

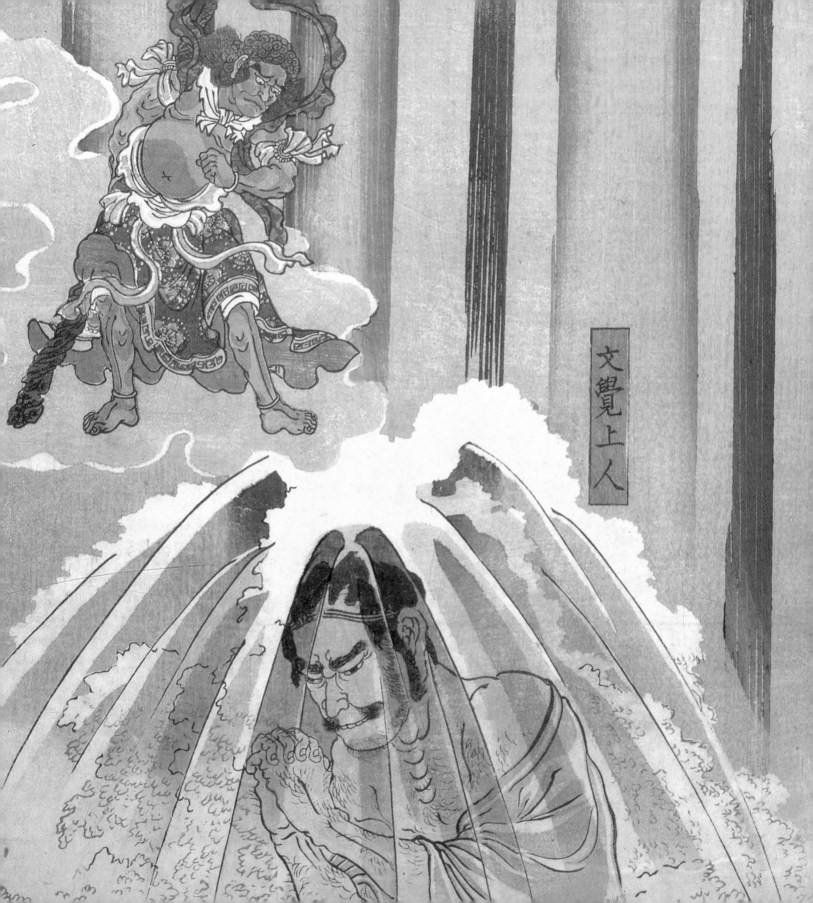

文覺上人

the block. Then the block-maker rubbed a pad of twisted hemp known as a *baren* over the back of the paper. When the paper was pulled away, it carried a facsimile of the artist's drawing.

A series of these "pulls" were used as further *hanshita-e* to make the other blocks. One was required for each color. Then the block-maker would set about carving the blocks for each component color, using the artist's drawing as a guide. There was not necessarily one block for each color in the finished print, and overprinting was also used. Green, for example, could be produced by overprinting blue and yellow.

Once the blocks had been cut, then the printer took over. First, he took the key-block and wiped ink over the raised areas again. The dampened handmade paper was placed on it and repeatedly rubbed with the *baren*. The inked outlines were then left to dry.

The printer mixed the colors, adding a little size made with rice to give it a solid consistency. Each block was covered in paint and each color printed in turn. It was here that the skill of the printer came into play. He had to wipe color onto the block to produce exactly the effect required. In some places a dense color was needed; in others a delicate tint. The paper was also absorbent and the printer would have to judge how much he thought the color would bleed. Sometimes it would bleed through to the other side of the print.

As the print passed from block to block, it was vital that the colors remained aligned. Key to this were the registration marks—*kento* or "aim marks" in Japanese—which were added by the block-maker. He would cut a right-angle notch cut into the corner of each block, which the paper would slot into. A straight line was cut in relief along the side of the block and kept the paper straight. How good the color registration was would depend on how accurately these marks were cut, the cut of the paper, and, to some extent, the dexterity of the printer.

Experienced printers could experiment with the different effects that could be produced by the same blocks. A completely new color scheme could be used on later impressions. Some blocks were even reused years later, by successors of the original publishers who could only guess at the intentions of the original artist.

Until the end of the nineteenth century, most colors were made from vegetable extracts. Exposed to light, the sky-blues, violets, and pinks have

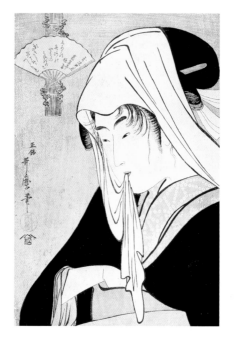

▲ **Kitagawa Utamaro (1753-1806)**
Tsujigimi

▶ **Chobunsai Eishi (1756-1829)**
Tomikawa Otami of the Matsubaya (c. 1800)

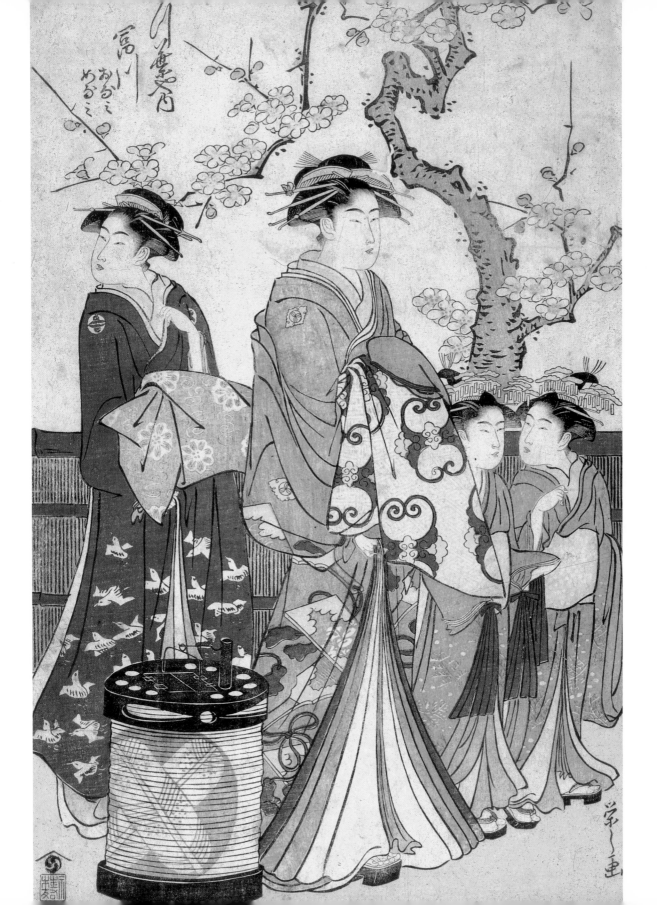

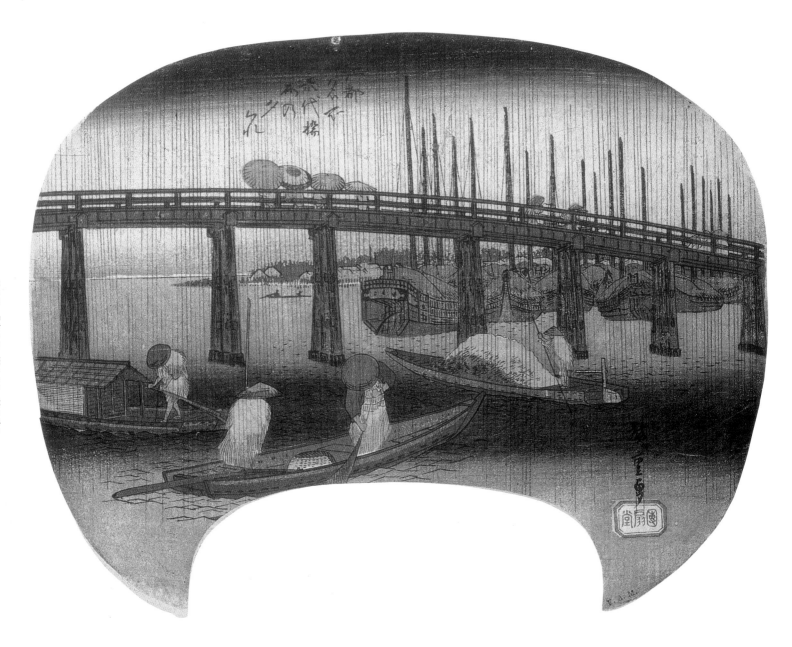

▲ **Utagawa Hiroshige (1797-1858)**

Evening Rain at Etai Bridge, from a series of fan prints (c. 1840)

sadly faded to buffs and grays. These are beautiful in their own way and collectors value their subtle, harmonious qualities. But they are nothing like the vivid colors of the prints when they were first manufactured.

As well as using a block to print each component color, gauffrage or blind printing was used to create the folds of a dress, animal's fur, or bird's plumage. Here a dry block, carrying no paint or ink, was pressed against the print to create a pattern on the paper in relief.

Mica was applied in backgrounds to give mirrors a shiny effect or to pick out ice or frosty surfaces. And metal dusts were applied either by sprinkling them on the finished print or by block.

Print runs in the eighteenth century were limited to two hundred. After that, the fine lines on the key-block began to wear down. Later the color blocks became so saturated with paint that they ceased to print the color evenly. However, during the nineteenth century, the demand for prints was so strong that runs were increased up to a thousand—some ran to 10,000 though the result would become increasingly shoddy. If any design was particularly successful, the blocks would be recarved from a copy of the original drawings and the series reissued.

Japanese prints are generally in one of two standard sizes—the *oban* which is approximately 15-by-10 inches (39 by 26 cm); or the *chuban*, which is approximately 101/2-by-8 inches (27 by 20 cm). However, a great many other shapes and sizes are also used. Earlier prints were usually vertical diptychs, or *kakemono*, which were often hung on rollers like Japanese paintings. Diptychs, tryptychs, and other multisheet prints show two or three pictures. Originally, these were separate images, linked by subject – though often the link is hard to spot. Early multisheet prints sometimes illustrate some obscure Zen theme. Consequently, they were often cut up and displayed separately.

However, in the late eighteenth century, Torii Kiyonaga began carrying a single design over two or three sheets. These were meant to be joined at the edges, but each sheet remains a work of art in its own right.

Prints were often issued in large series, kept in boxes, or mounted in albums. They started in sets of ten or twelve, but by the conclusion of the eighteenth century a series ran anywhere from thirty-six to over a hundred.

Sometimes five sheets or more were joined together horizontally and rolled up like a *makimono,* or scroll painting. Also like scroll paintings,

these usually depicted a great panoramic scene, which could best be viewed frame-by-frame as the viewer would unroll the print off one roller and on to the other.

The Japanese printmakers also made *hashira-e*, which are tall, vertical multisheet prints to hang down the wooden pillars—or *hashira*—which supported the roofs of Japanese buildings. This tall narrow shape is a uniquely Japanese format and helped to push the printmakers to the very limits of their creativity.

As well as selling direct to the public, printmakers often made specially commissioned *surimono*—which simply means printed things. These included decorated poetry, New Year's greetings, the announcement of a birth or marriage, or notice that an author or artist had changed their name —a surprisingly frequent occurrence. Usually, these were small, and filled with fine detail and lavish printing.

There were also large, oversized prints, usually depicting beautiful women. The size was thought to enhance their beauty. However, these were suppressed by government edicts of the Kyoho era, which sought to curb excesses of all kinds.

▶ **Kitagawa Utamaro (1753-1806)**
The Courtesan Ajeraki and Her Gallant

▶ **Suzuki Harunobu (1725-1780)**
Two Lovers at a Gate

▶ **Suzuki Harunobu**
The Assignation

How They Were Made

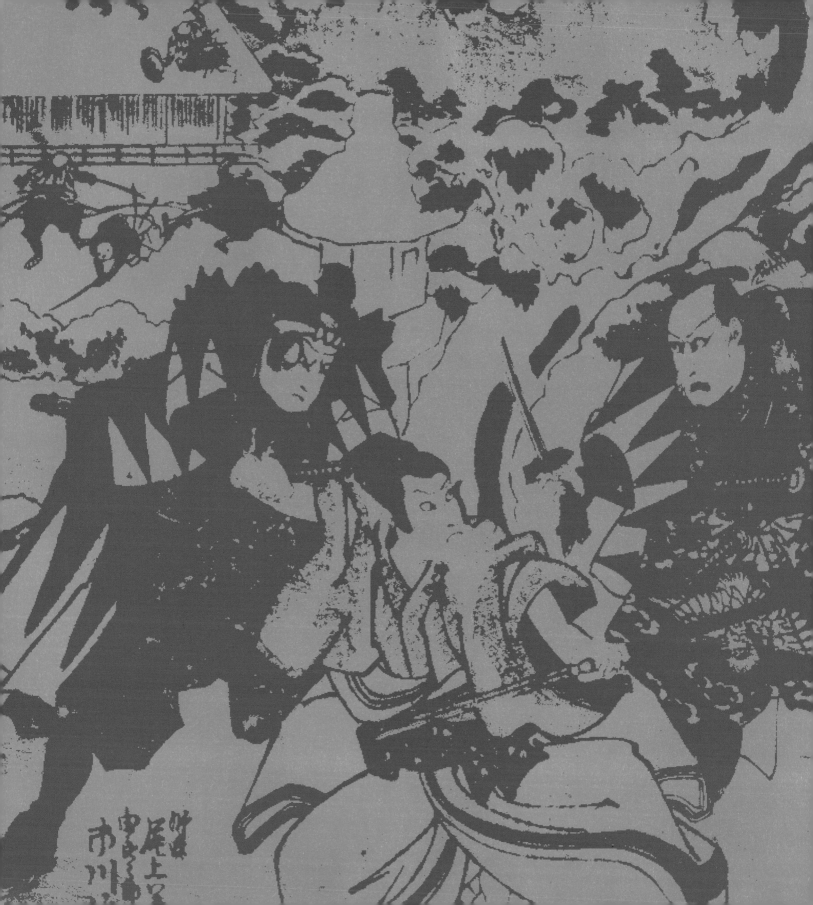

Hishikawa Moronobu (1618-1694) was the first great master of the Japanese print. He was responsible for freeing prints from their role as purely book illustrations. Thus, he is considered the father of *ukiyo-e*.

He was born into a family of brocade embroiderers in Hoda, east of Tokyo Bay. After his father's death, he went to Edo and studied under the Kambun Master—an anonymous artist whose unsigned *ukiyo-e* paintings and early prints appear from about 1660 to 1674. Moronobu's earliest signed works, both dated spring 1672, are the illustrated book *Buke Hyakunin Isshu—One Hundred Samurai Poets*—and a painted scroll which depicted scenes from the Yoshiwara. He illustrated over a hundred and fifty books. Subjects included kimono patterns, guides to the Tokaido Road linking Edo to Kyoto and the Yoshiwara district, and many erotic prints.

The Kambun Master died in 1674, and Moronobu was acknowledged as the leading *ukiyo-e* artist of his day. His bold brush-strokes were well suited to the medium of the woodblock and in the following two decades he established a style that would be followed for two centuries. At the same time, Sugimura Jihei, who produced a large number of erotic prints in the 1680s and 1690s, was at work. His style resembles Moronobu's, but nothing is known of his life.

Moronobu passed on his skills to his pupils—Sugimura, Moroshige, and Tomonobu (also known as Ryusen). Moronobu's son Morofusa also studied under him, but quit *ukiyo-e* to go into fabric dyeing and kimono design, which was more akin to the family's traditional trade.

Moronobu's influence was to spread far beyond his own studio. The Kaigetsudo school under Kaigetsudo Ando (active 1700-1714), flourishing in the early eighteenth century, began producing *ukiyo-e* prints which depicted beautiful, full-figured women in the style of Moronobu.

The Torii school also took its inspiration from Moronobu. Its founder, Torii Kiyonobu was born in Osaka around 1664. He was the son of Torii Kiyomoto, a *Kabuki* actor who also painted the large, colorful billboards on display outside the theater.

In 1687, the Torii family moved to Edo, where the young Kiyonobu fell under the spell of Moronobu, producing his first illustrated book that same year. In 1700, he produced his *Actor Book,* showing the *Kabuki* stars of the time in action, and the *Courtesan Book,* showing the great beauties of the Yoshiwara pleasure district.

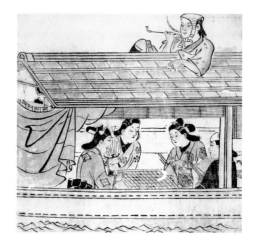

▲ **Hishikawa Moronobu (1618-1694)**
Riverboat Party

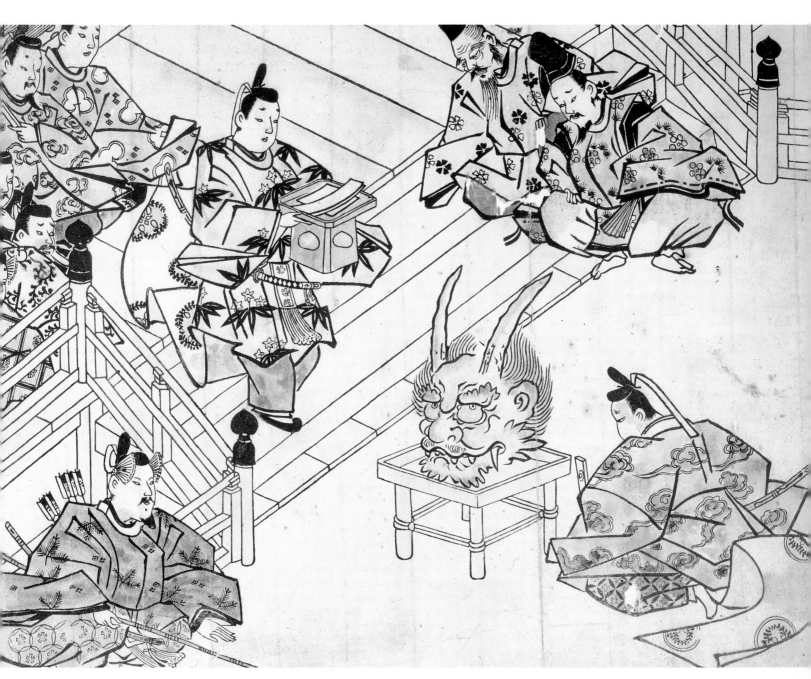

▲ **Hishikawa Moronobu**
Raiko and Shutendoji

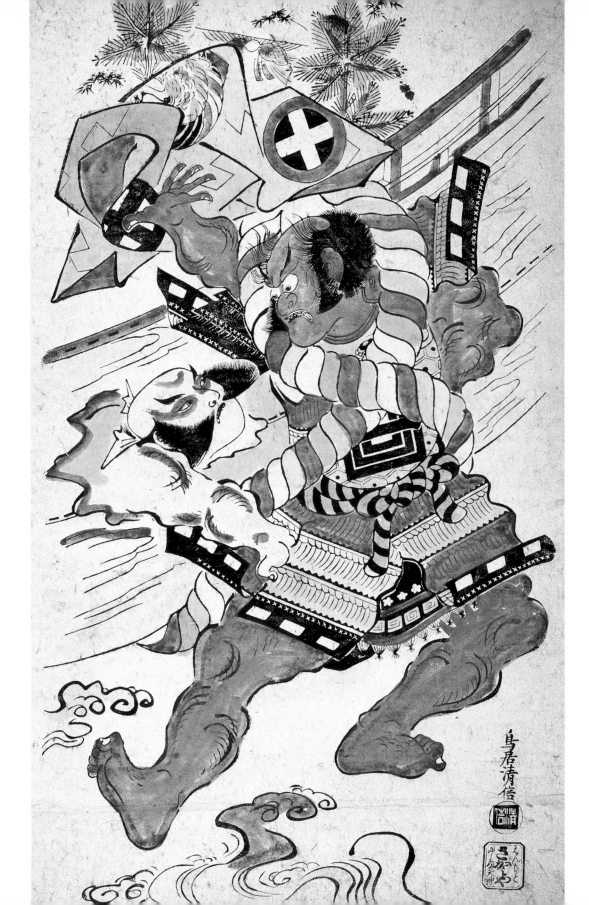

Torii Kiyonobu rose to fame with *Kabuki* star Ichikawa Danjuro I, who popularized the exaggerated *aragoto*—rough—style of acting. It was a highly stylized method and emphasized superhuman strength. To portray this in print, Torri Kiyonobu devised a distinctive style using strong lines in order to accentuate the muscles.

This style was further developed by Kiyonobu's son, Torii Kiyomasu (active 1694-1716) who became the second titular head of the Torii school. He was succeeded by Kiyomitsu (1735-1785). There is some confusion over the output of these men as there names were also used by other artists of the Torii school. Prints from 1729 to 1763 are attributed to another artist Kiyonobu II, and the work of one or more artists active from the mid-1720s to 1763 is ascribed to a Kiyomasu II.

There were other masters of the Torii school at that time—Kiyotada (active 1718-1750), Kiyoshige (active in the 1720s) and Kiyotomo (active 1720-1740). Kiyohiro (active 1760-1770) worked at the same time as Kiyomitsu. The artists adopted the new color processes that were rapidly coming in and added a new elegance to the style. This allowed them to depict the beauty of the *onnagata*, the female impersonators in the *Kabuki*, and also women proper; particularly the mildly erotic after-bath pictures of women.

Okumura Masanobu (1686-1764) was self-taught, but learned his art by studying the work of Torii Kiyonobu. Masanobu was a great innovator. He developed the *uki-e* or "floating picture," which incorporated a Western sense of perspective. His other innovations were *habahiro-hashira-e*—wide pillar pictures—and *beni-e*—pink pictures. These were hand-colored with pink. The pink areas were then covered with lacquer or glue to add luster. Later, these developed into *benizuri-e*, or pink-printed pictures.

Nishimura Shigenaga (active from around 1720 to 1756) invented *san-puku-tsui*—narrow triptychs and *ishizuri-e*—stone-painted pictures. These were reverse images, with white lines picked out of a black or colored printed background. His pupil was Ishikawa Toyonobu (1711-1785), who was an inn owner and part-time print-designer specializing in *benizuri-e* and *urushi-e*, where lacquer or glue is applied to the black areas.

Suzuki Harunoba (1725-1770) introduced multicolored or polychrome prints. He studied under Shigenaga but began work making actor prints in the style of Torii Kiyomitsu. When Harunoba was commissioned by a haiku

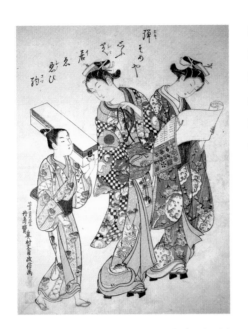

▲ **Okumura Masanobu (1686-1764)**
Girls Going to the Theater (c. 1750)

◄ **Torii Kiyomasu II (active 1720-1763)**
Actors in the Roles of Soga no Goro and Asahina Saburo

Masters and Movements

poetry society to produce a calendar for 1765, he found that a new and thicker paper had been developed that could withstand printing several times. At the same time, the *kento* system of registration notches had been devised, so colors could be aligned easily. This allowed Harunoba to produce full-color *nishiki-e*—or brocade pictures. While it was, in fact, the paper- and block-makers who had actually made these innovations, as Harunoba was the first artist to work in the new medium, he has been credited with the breakthrough.

Shiba Kokan (1747-1818) worked in Harunobu's studio under the name of Suzuki Harushige. In his autobiography, he admits to having forged the signature of Harunobu on his own work and passing it off as that of the master. However, his designs—even when they appear under Harunobu's name – are distinguished by the extreme perspective of the background. Under his real name, Kokan, he became the first Japanese artist to utilize copperplate printing.

Katsukawa Shunsho (1726-1792) brought a new realism to the *yakusha-e* or actor print and the *bijin-ga*, portrait of a beautiful woman. Along with his pupil Katsukawa Shunko (1743-1812), he added prints of Sumo wrestlers to the *ukiyo-e* canon. These became a staple of the Katasukawa school, along with the *okubi-e*—half-length portrait—of *Kabuki* actors. Another student, Katasukawa Shunyei (1762-1819), began producing *musha-e*—warrior prints—as well.

In 1770, Katsukawa Shunsho collaborated with Ippitsusai Buncho (active 1765-1792) on the noted *Ehon butai-ogi* (A Book of Stage Fans) in 1770. This was a three-volume collection of actor prints in fan-shaped frames. Buncho started his own school, which spawned Yanagi Buncho (active from the 1760s to the 1790s) and his pupil Buncho II (who was also active in the late 18th century).

After the introduction of full-color printing, there followed what has been called the golden age of *ukiyo-e* prints. One of its leading proponents was Isoda Koryusai (active 1765-1780s), who relinquished his rank of samurai to become an *ukiyo-e* artist. This was unusual to say the least. The samurai were supposed to be followers of Confucianism, which denies the beauty of woman and preaches shame to the men who are attracted by women's charms. Theoretically, samurai were not allowed into Yoshiwara or the *Kabuki*.

▲ **Katsukawa Shunsho (1726-1792)**
Lovers Becoming Familiar

▶ **Suzuki Harunobu (1725-1770)**
Collecting Insects by Lamplight (c.1768)

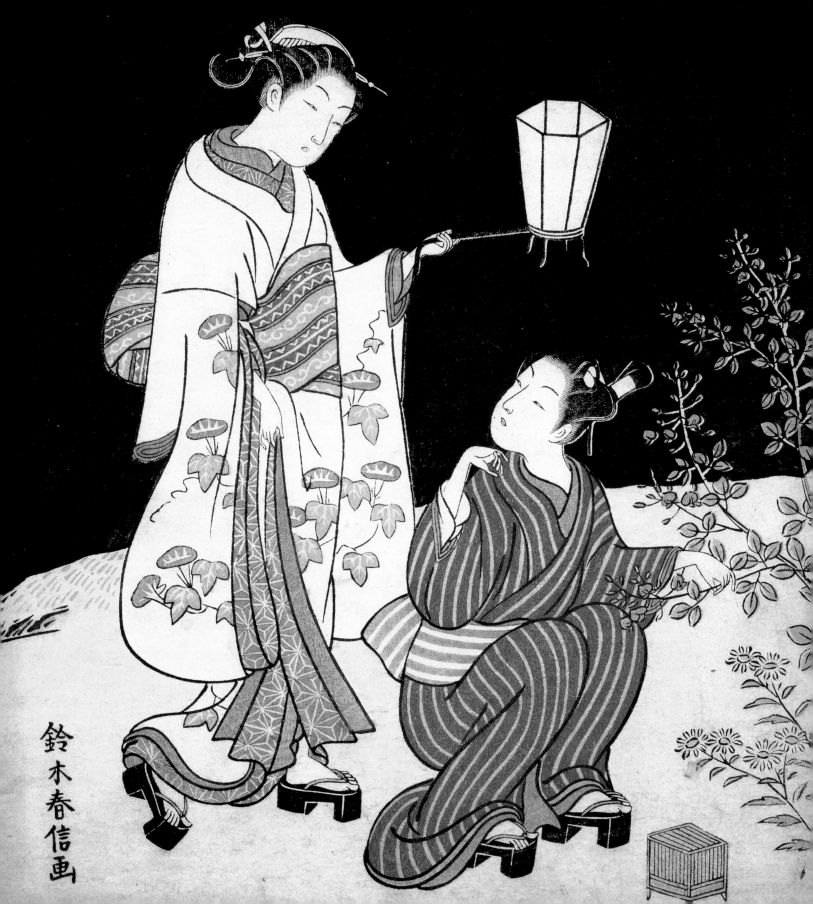

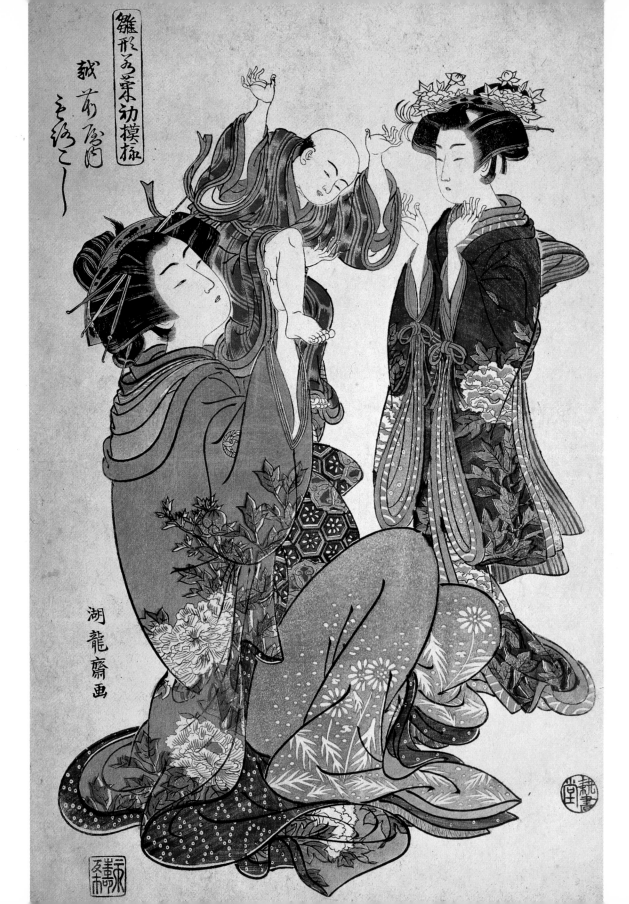

Koryusai initially used the name Haruhiro and may have been one of the students of his friend Harunobu. He brought a new realism to his *bijin* prints. At the height of his career, he produced a series of a hundred called "Hinagata Wakana-no-Hatsumoyo" (Courtesans in New Year Fashion Dresses). He excelled at *hashira-e*—pillar-pictures, and *kacho-ga*—bird and flower pictures. Toward the end of his career, though, he turned toward painting—which was, after all, a more suitable medium for a samurai.

Torii Kiyonaga (1752-1815) was the fourth head of the Torii school. Although many in the Torii school were members of the family, Kiyonaga was not. Like many students of the time, he took the name of his master. He was the son of a bookseller, so he had a great opportunity to study illustrations when young. A pupil of Torii Kiyomitsu, he produced realistic *Kabuki* prints, showing for the first time not only the dressing rooms but also the singers and musicians on stage. Later, he turned his attention to *bijin-ga* and produced large-size *nishiki-e*, which depicted statuesque and tall women. His realistic style, with its poetic and evocative undertones, dominated *ukiyo-e* for twenty years.

◄ **Isoda Koryusai (active 1765-1788)**
The Courtesan Morokoshi of Echizan with Child and Attendant (c. 1776)

► **Torii Kiyonaga (1752-1815)**
Kabuki Scene with Part of the Chorus

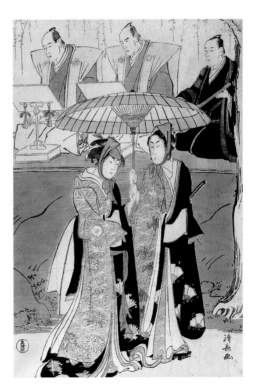

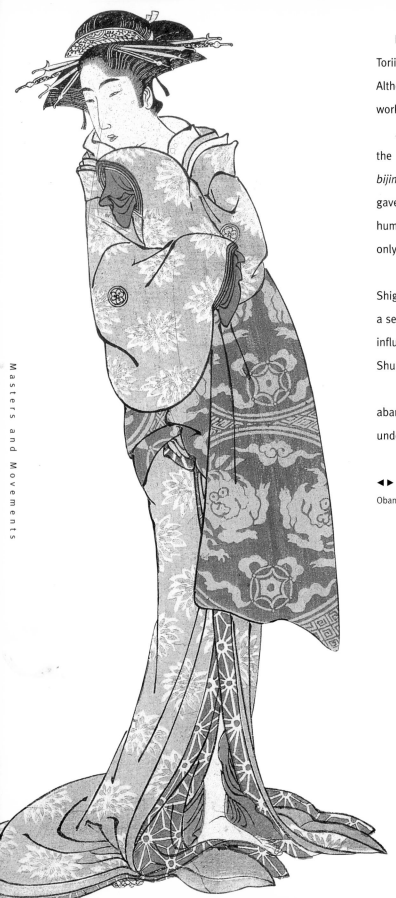

It is said that he put up Torii Kiyomine (1787-1868) – one of the main Torii family—as his successor and forced his own son to give up painting. Although in many ways Torii Kiyomine was an unworthy successor, his later works appear under the name Kitomitsu.

Although Katsukawa Shuncho (active 1770s-1790s) was a member of the Katsukawa school and a student of Shunsho, he found his ideal in the *bijin-ga* of Torii Kiyonaga at his peak and seldom varied from that style. He gave up printmaking early on and devoted himself instead to writing humorous verse in the *kyoka* style, which limits itself strictly to the use of only thirty-one syllables.

Also active at the time was the Kitao school of illustrators. Kitao Shigemasa (1739-1820) was the son of Edo book publisher Suhara-yu and a self-taught artist. However, his original style in depicting beautiful women influenced Torii Kiyonaga and others. In turn Kiyonaga influenced Kubo Shunman (1757-1820), who was one of Kitao Shigemasa's pupils.

Kitao Masanobu (1761-1816) initially studied under Shigemasa, but abandoned *nishiki-e* and eventually went on to win fame as a fiction writer under the name Santo Kyoden.

◄ ► **Kitao Masanobu (1761-1816)**
Oban Diptych from the Autographs of Yoshiwara Beauties (detail left)

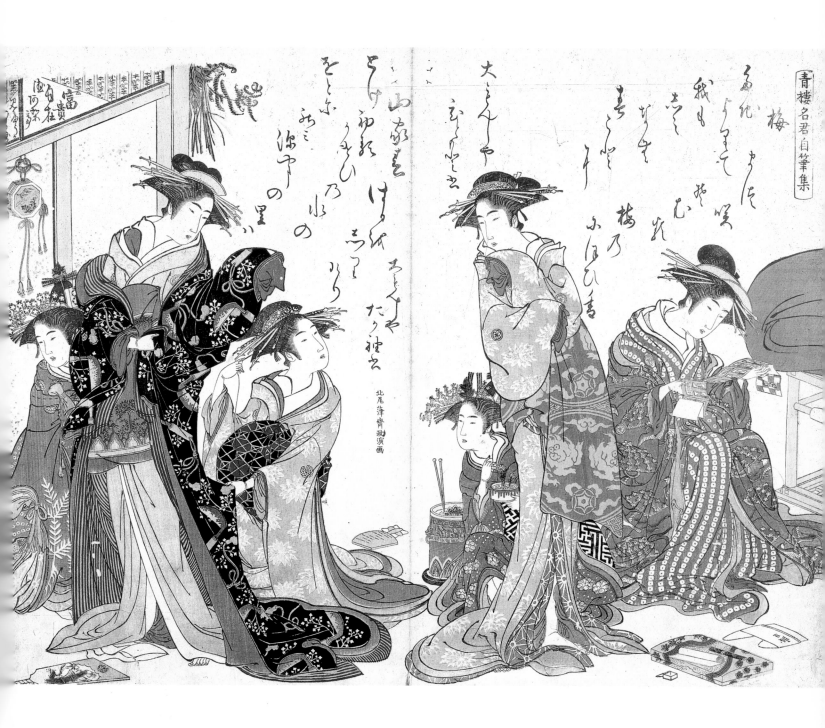

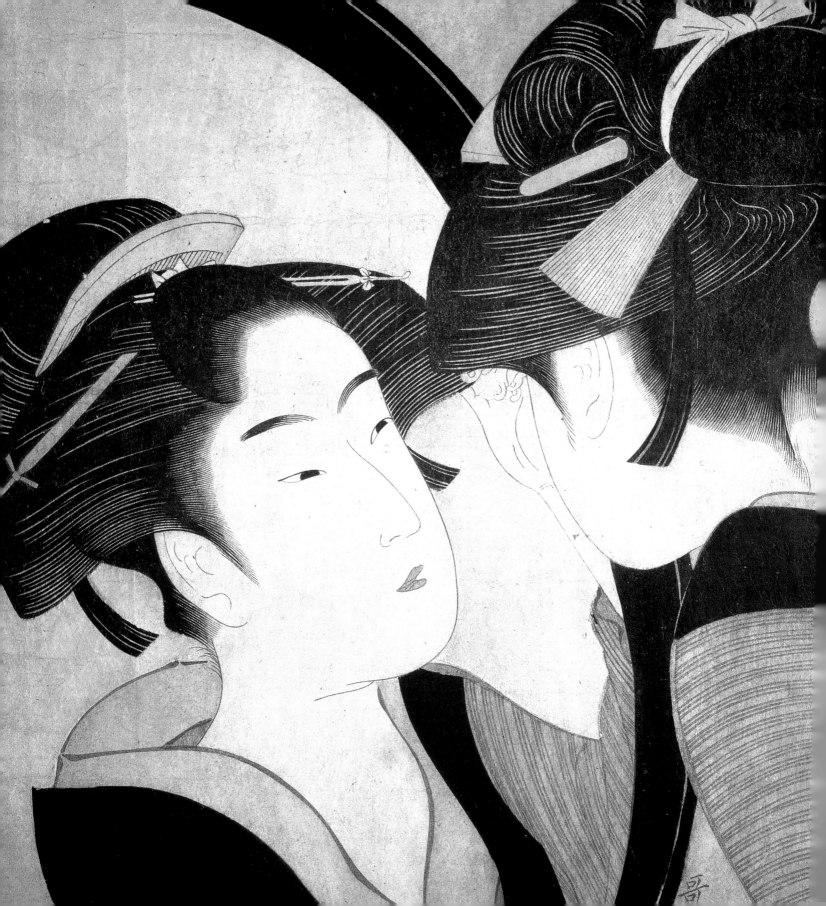

Another of Shigemasa's pupils, Kitao Masayoshi (1764-1824) introduced perspective to prints of warriors, beautiful women, and birds and flowers. He quit in 1797 to become a painter in the service of the *daimyo*—feudal lord—of Tsuyama and changed his name to Kuwagata Keisai.

But the greatest artist of the golden age of *ukiyo-e* was undoubtedly Kitagama Utamaro (1753-1806). Though he achieved fame for a seemingly lifelong pursuit of female beauty, he began his career—like so many other *ukiyo-e* artists—making portrait prints of actors and also illustrating books, poems, and playbills.

Utamaro was a student of the painter Toriyama Sekien (1714-1788) and initially used the name Toyoaki. He changed his name to Utamaro in 1781 and, shortly afterward, he moved into the home of the publisher Tsuta-ya Juzaburo (1750-1797).

He began illustrating Tsuta-ya Juzaburo's books of *kyoka*, but soon his illustrations began to dominate the works of even the most famous *kyoka* poets. He had a keen eye for nature, producing *Mushi Erami (The Insect Book)* in 1788, which featured frogs, snakes, and flowers as well as insects, and *Momo Chidori Kyoka Awase (A Chorus of Birds)* in 1789.

◀ **Kitagawa Utamaro (1753-1806)**
Girl with a Mirror

▶ **Kitagawa Utamaro**
Two Female Figures

▶ **Kitagawa Utamaro**
(Overleaf) Chinese Ballon Flower and Insects and Flowers,
from *The Insect Book* (1788)

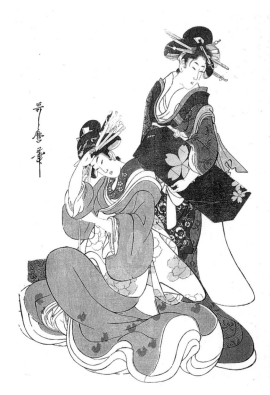

赤蜻蛉

赤蜻蛉

朱樂菅江

いかに

彩霞杉丸

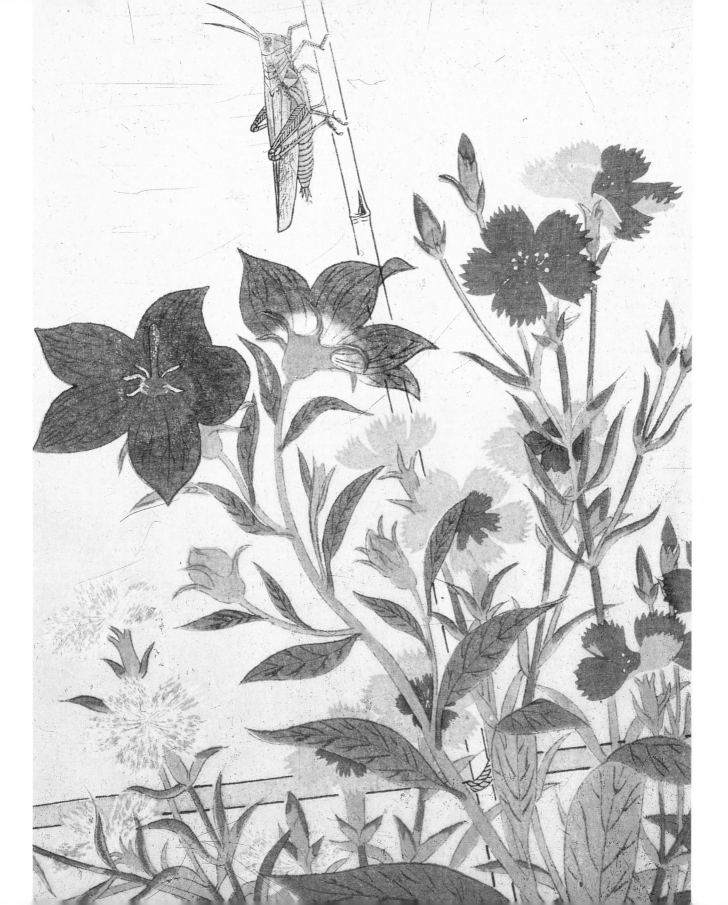

However, he did not ignore the more traditional *ukiyo-e* themes. His illustrations for *Uta Makura* (Pillow Poems) secured his fame and led to a great deal of erotic work. Despite the severe censorship of the times, he only fell foul of the law briefly in 1804, for a satirical work.

From the early 1790s, he began to concentrate on *bijin-ga*, making large *oban*-size prints showing beautiful women in close-up. He brought emotion to the subject, often depicting the yearning and suffering of love. Unlike the other great *bijin-ga* artist of that period, Torii Kiyonaga, he showed his women alone without a background or against a simple tone.

He also produced triptychs, with groups of beautiful women full-figure. And he did not merely idealize the beauty of famous courtesans. He showed the grim reality of everyday life and was the first *ukiyo-e* artist to depict drunken, lower-class prostitutes.

Eishosai Choki (active 1780-early 1800s) also studied under Toriyama Sekien, but his style owes more to Harunobu than Utamaro. Like Utamaro, he depicts women in extreme close-up, but pays much more attention to background. Much of his output was run-of-the-mill, but a few of his color prints rank with the best produced by a *ukiyo-e* master.

Tamagawa Shucho (active 1790s-early 1800s) was around at the same time. Although he was a pupil of Buncho, his major influence is Utamaro. But his works are few and his life obscure.

Utamaro's great rival was Chobunsai Eishi, (1756-1829), the son of a leading samurai family. His grandfather had been treasury minister in the Shogun government. Eishi himself was trained in the studio of official painter Kano Eisen-in, but in the early 1780s he resigned his position, quit as head of the family, and began pursuing a career in *ukiyo-e*.

Initially, he modeled his style on Shigemasa. Then, like most *bijin-ga* artists, he fell under the influence of first Kiyonaga and then Utamaro. However, his prints never lose their aristocratic detachment. His women appear sublime, untouched by the real world and its cares.

Although not strikingly original, Eishi did not wish to be bothered by the vagaries of popular taste. And when the quality of *ukiyo-e* prints went into decline toward the end of his career, he turned to painting, where he also became an acknowledged master. He was mentor to a whole raft of other artists—Eisho, Eiri, Eisui, Eishin—who were all active in the world of *ukiyo-e* in the 1790s.

▶ **Chobunsai Eishi (1756-1829)**
A Beauty from the Pleasure Quarter

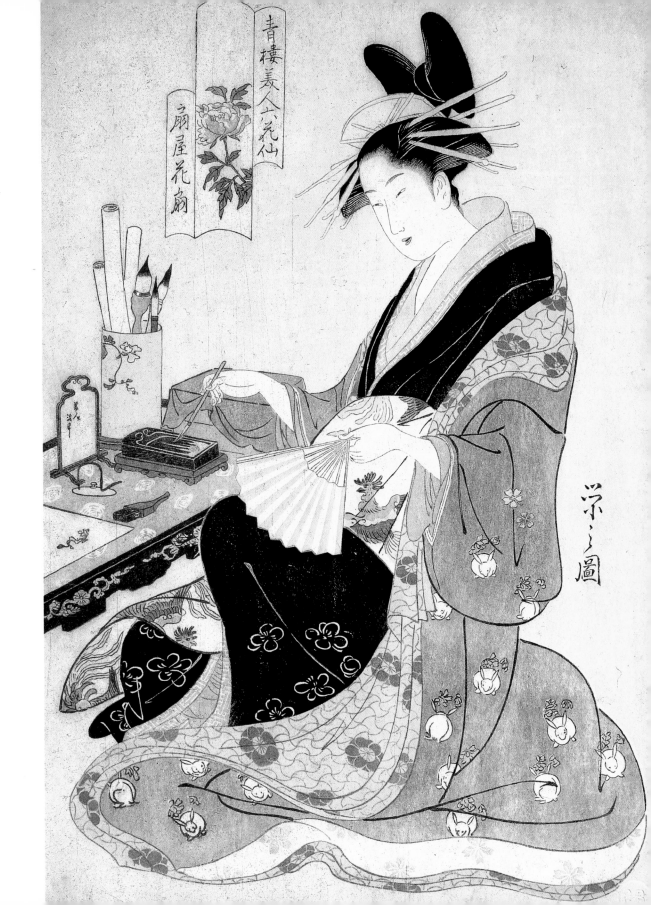

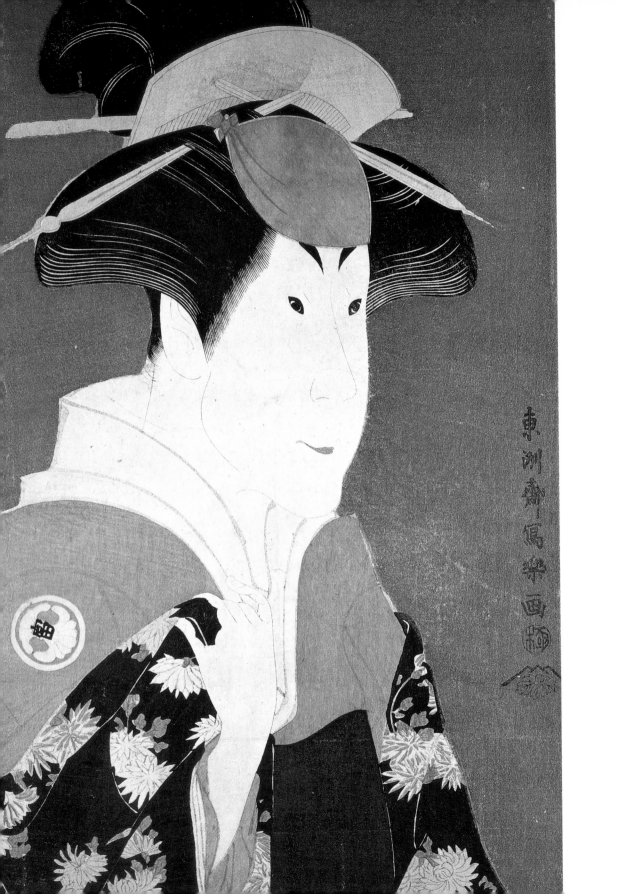

東洲斎写楽画

In May 1794, the publisher Tsuta-ya was in trouble. In a government crackdown, his publications had been suspended and half his property confiscated. The *bijin-ga* of Utamaro's he was publishing could scarcely be rivaled, so he needed some actor prints to recoup his losses.

The artist he picked to produce them was a complete unknown, Sharaku (active 1794-1795). Little or nothing is known about him, but he produced a series of startling prints in *kirazuri*—a method of printing using powdered mica to give a silvered effect. They brought with them a new realism and a psychological depth unknown in actor prints. These bold close-ups were clearly the work of a genius, and they took Edo by storm. Sharaku produced over 140 prints within ten months. Then he suddenly disappeared completely. Tsuta-ya Juzaburo died two years later without revealing Sharaku's identity or what had happened to him.

Some scholars believe that Sharaku was a famous artist like Hokusai. Others think he may have been a *Noh* actor, moonlighting. Such things were not entirely unknown. Kabukido Enkyo, who produced seven prints in the style of Sharaku, has now been identified as the dramatist Nakamura Jusuke II (1749-1803).

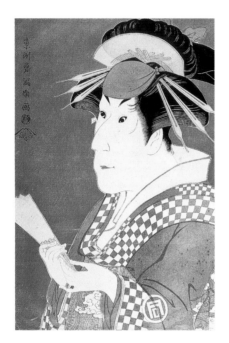

▲ **Toshusai Sharaku (active 1794-1795)**
The Actor Sanokawa Ichimatsu III as the Geisha Onayo of Gion (1794)

◄ **Toshusai Sharaku**
The Actor Segawa Tomisaburo as Vadorigi (1794)

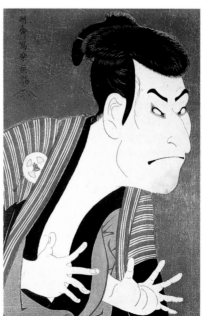

▲ **Toshusai Sharaku**
The Actor Otani Oniji as Eitoku

Although the Torii school has lasted longest—some members are still active to this day—the Utagawa school was the biggest. Its artists almost completely dominated *ukiyo-e* in the final era of the Edo period.

It was founded by Utagawa Toyoharu (1735-1814), who had studied under the classical *Kano* master Tsuruzawa Tangei in Kyoto. He went to Edo in about 1763 and became a pupil of Shigenaga and Sekien, though he was more obviously influenced by Toyonobu and Harunobu.

He began producing *uki-e*, perspective prints. Although most *uki-e* artists seem to have got the idea from Chinese woodblocks, Toyoharu seems to have been more familiar with Western copperplates. One of his landscapes apes a copperplate print by Antonio Visentini (1688-1768), which is based on "Grand Canal looking Northeast from Santa Croce to San Geremia" by Canaletto (1697-1768).

Although he shows off his *uki-e* skills in some indoor scenes such as "Perspective View of Shingawara Pleasure House," he also depicted some outdoor scenes, portraying the sights of Edo and the festivals in Kyoto. Consequently, he is regarded today as one of the great pioneers of the original landscape print.

Utagawa Toyohiro (1773-1829) joined Toyoharu's studio in 1782. Like his teacher, Toyohiro was interested in landscape, but also took great interest in *bijin-ga*. His masterpiece is the beautiful triptych series "Ryoga Juniko" (Twelve Months Portrayed) which he produced in collaboration with another of Toyoharu's students, Utagawa Toyokuni (1769-1825).

Toyokuni was said to be the son of a man who made puppets in the likeness of Ichikawa Danjuro II, one of the greatest actors of the day. He lost his parents when he was young and joined Toyoharu's studio, where he concentrated on his *nigao-e*, "likeness pictures" of actors. A brief but productive period of rivalry with Sharaku stimulated his finest work, the forty prints called "Yakusha butai no sugata-e" (Pictures of Actors in Character) which were produced in 1795-1796.

Torokuni also produced *bijin-ga*. But instead of depicting tall, slim women like Toyohiro, he showed small women with sloping backs.

The artist Toyoshige (1777-1835) became the adopted son of Torokuni and signed himself Utagawa Toyokuni II. He could not match his father's *nigao-e* or *bijin-ga*. But in his later years he produced some outstanding landscapes in "Meisho Hakkei" (Eight Views of Famous Places).

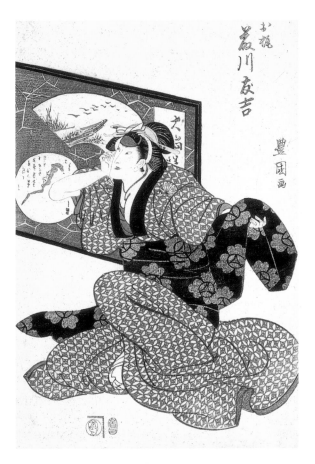

▲ **Utagawa Toyokuni (1769-1825)**
The Actor Fujikawa Tomokichi II as O-Kaji (c. 1811)

▶ **Utagawa Toyokuni**
Two Girls and a Youth on a Beach (c. 1780)

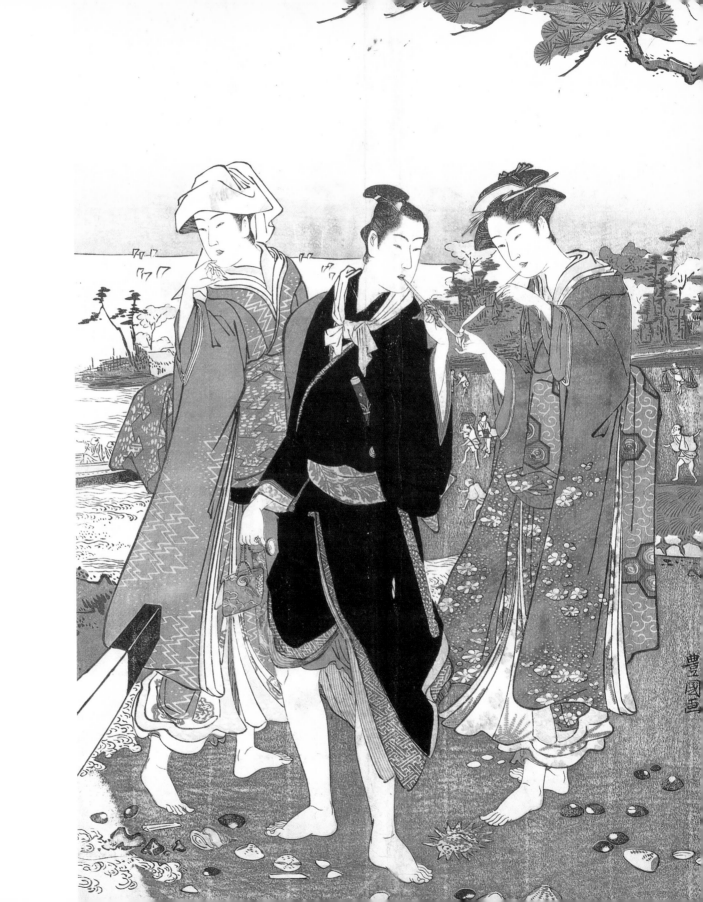

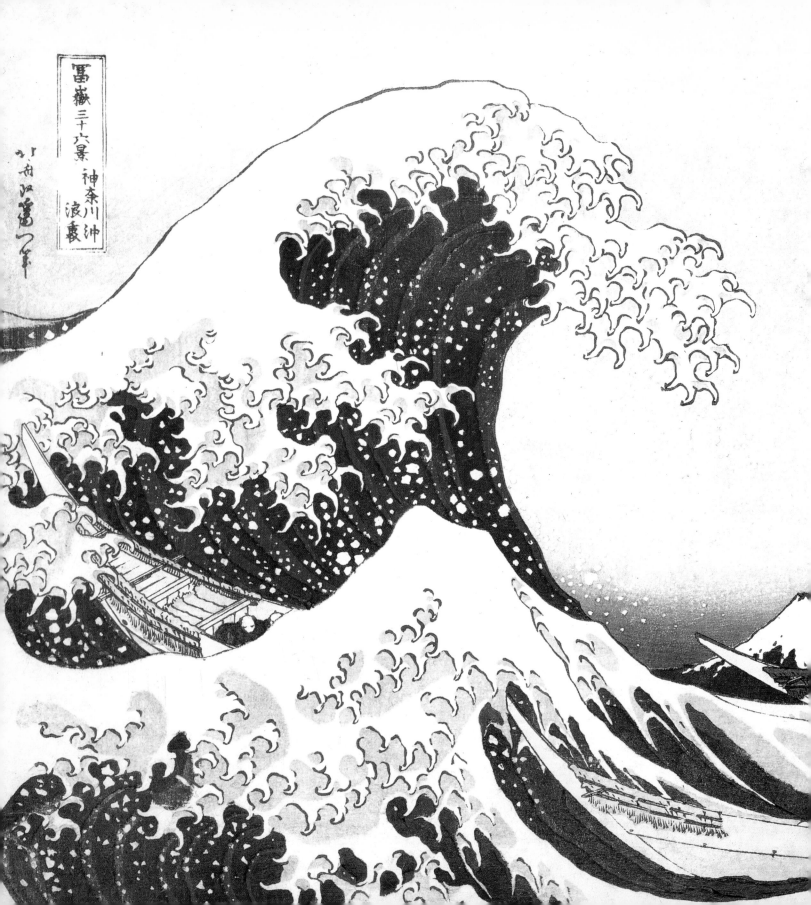

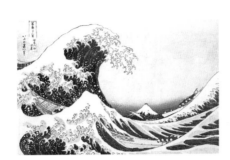

▲▲ **Katsushika Hokusai (1760-1849)**

The Great Wave of Kanagaw (detail opposite) from the series "36 Views of Mount Fuji" (1831)

▶ **Katsushika Hokusai**

(Overleaf) Women Gathering Waterlillies from the series "100 Poems Explained by the Poets"

Toyokuni had a number of pupils. His first was Utagawa Kunimasa (1773-1810), who made actor prints *okubi-e* style. Utagawa Kunitora (active during the early nineteenth century) concentrated on landscapes. He was also influenced by Western copperplate prints and produced a picture that portrayed a large bronze statue at the end of the harbor at Rhodes. Many of his landscapes also portray a wave-like quality which, it is thought, may have influenced Hiroshige.

Other pupils of Toyokuni include Kuninaga (1790-1829), Kininao (1793-1854), Kuniyasu (1794-1832), and Kunimaru, who was active during the early nineteenth century.

The great master of the landscape, Katsushita Hokusai (1760-1849), was a pupil of Katsukawa Shunsho, after first serving an apprenticeship as a wood-block engraver. At the age of nineteen, he produced his first works—actor prints—under the name Shunro. In the 1780s, he produced notable figure prints under the name Kako. Then in 1797, he changed his name to Hokusai—which means Northern Star.

His artistic identity, had still not consolidated, however—he took to imitating copperplates of the Dutch school and studied Chinese painting and graphic art. He also studied secretly under the classical Kano master Yusen (1778-1815). When Katasukawa Shunko—who was then head of the Katasukawa school—found out, Hokusai was expelled. He later fell out with Yusen, after criticizing Yusen's depiction of children, and was thrown out of the Kano school, too.

Hokusai displayed his vast knowledge of all styles of art in his fifteen *Manga* sketchbooks published from 1814 onward. However, his main impact was on landscape. "Thirty-six Views of Mount Fuji," published in the early 1830s, made him famous and in 1834 and 1835 he produced the three-volume "One Hundred Views of Mount Fuji." Although it can be argued that he had stepped outside *ukiyo-e* in the very strictest sense, he did revitalize the medium and made the landscape and flower-and-bird prints the dominant genre.

Totoya Hokkei (1780-1850) followed Hokusai from the Kano school and became his pupil. The name Totoya means fishmonger—his family had been fishmongers to a *daimyo*. As well as producing book illustrations and *surimono*, he also created the print series "Shokoku Meisho" (Famous Places in Various Provinces).

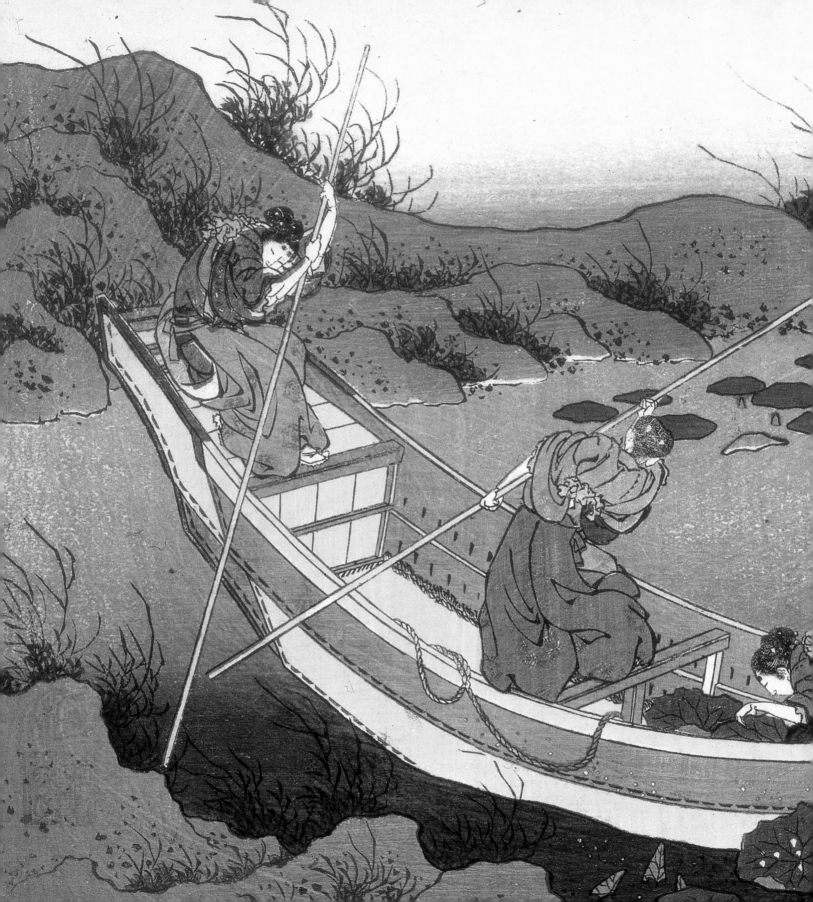

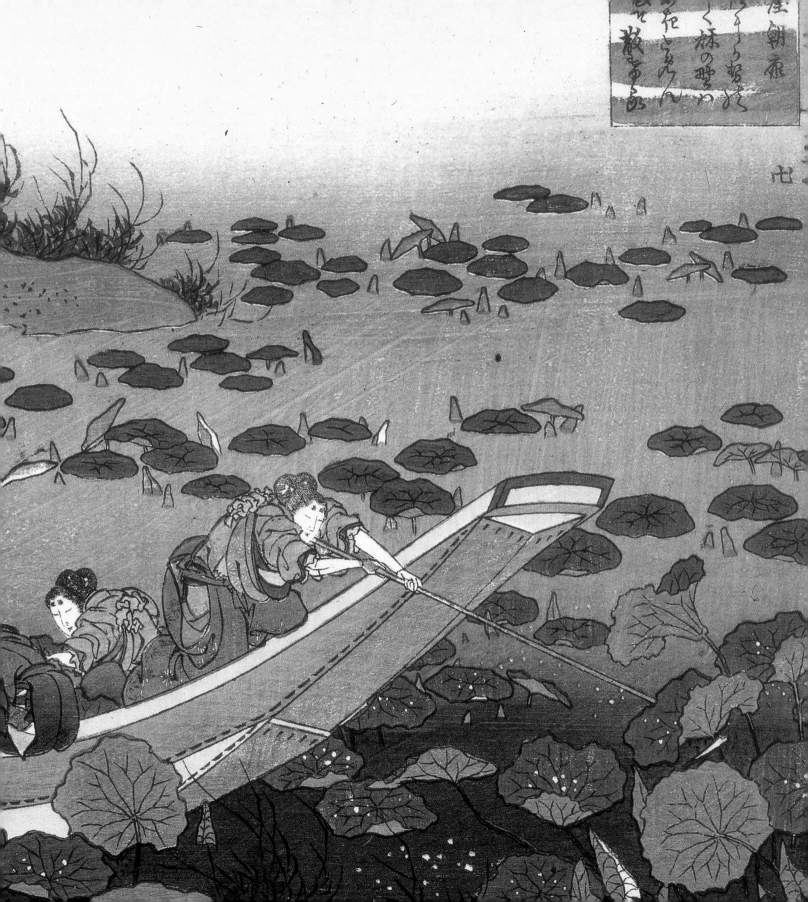

Another of Hokusai's pupils was Shotei Hokuju (active from the later 1790s to the mid-1820s). He developed a highly original style, based on a necessarily scant knowledge of European art. His landscapes were cubist, his clouds highly stylized, and his figures near-photographic. His prints seem to owe nothing to the late eighteenth and early nineteenth century, but look curiously modern.

The last great master of the *ukiyo-e* was the famous Utagawa Hiroshige (1797-1858). He was a low-ranking samurai, his father was the firewarden at Edo castle. By the age of ten, Hiroshige was producing very impressive paintings, and in 1811 he entered the studio of Utagawa Toyohiro, where he took the name Hiroshige. From 1818 on, he produced actor prints, warrior prints, and *bijin-ga*.

When he was twenty-seven, his father died. Hiroshige passed on the headship of the family to his uncle, devoting himself to *ukiyo-e*. As Hokusai's influence grew, Hiroshige followed him into landscapes. In 1831, in response to Hokusai's "Thirty-six Views of Mount Fuji," he published "Tokaido Gotusantsugi" (Fifty-three Stations on the Tokaido Road). The series depicts Hiroshige's journey along the road from Edo to Kyoto. He

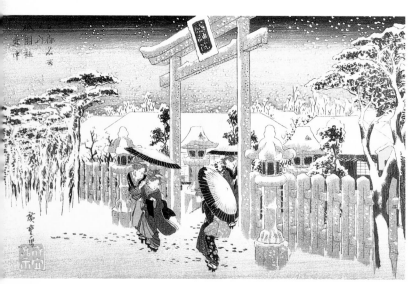

◄ **Utagawa Hiroshige (1797-1858)**
Gion Temple in the Snow, from the series "Famous Places in Kyoto"

▶ **Utagawa Hiroshige**
A Seascape from the series "60-Odd Famous Views of the Provinces" (1853)

▶ **Utagawa Hiroshige**
(Overleaf) The Lady Fujitsubo Watching Prince Genji Departing in the Moonlight (1853)

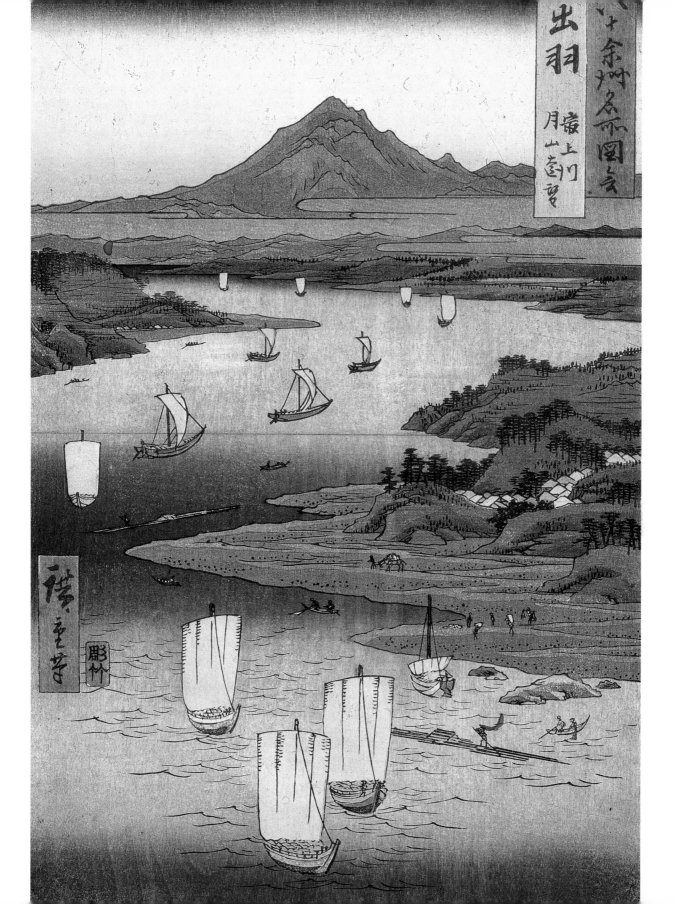

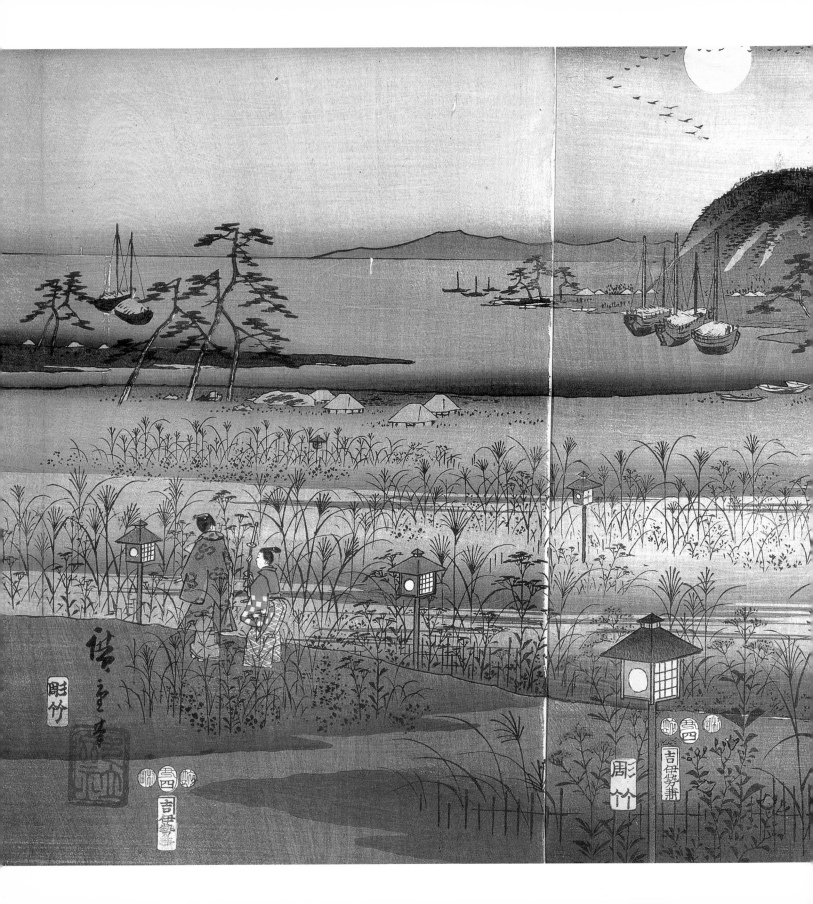

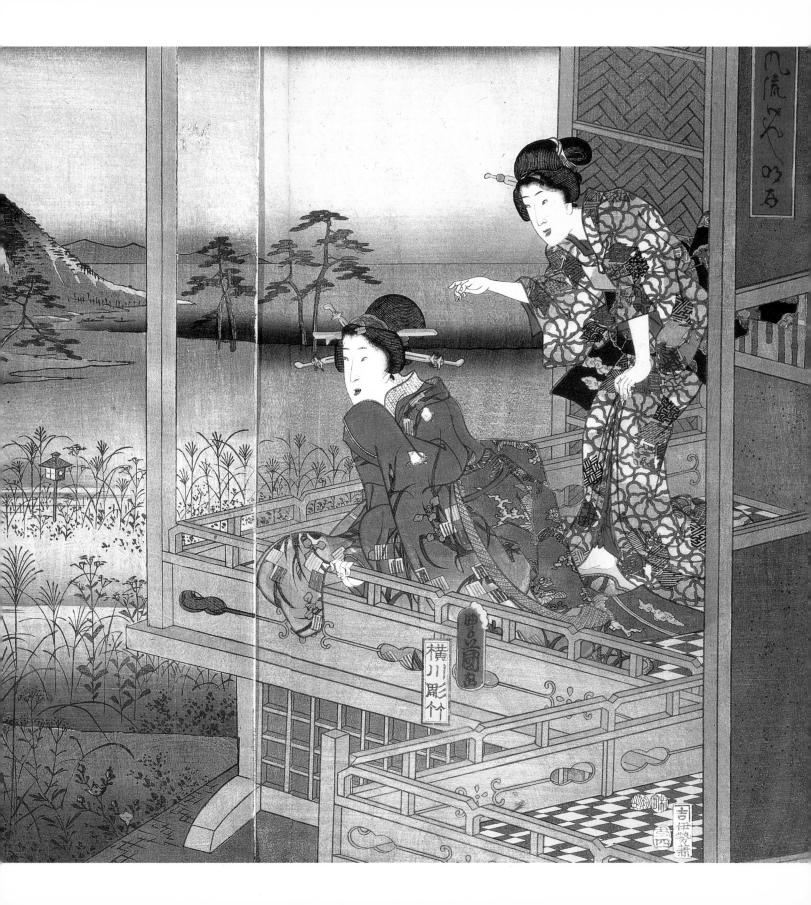

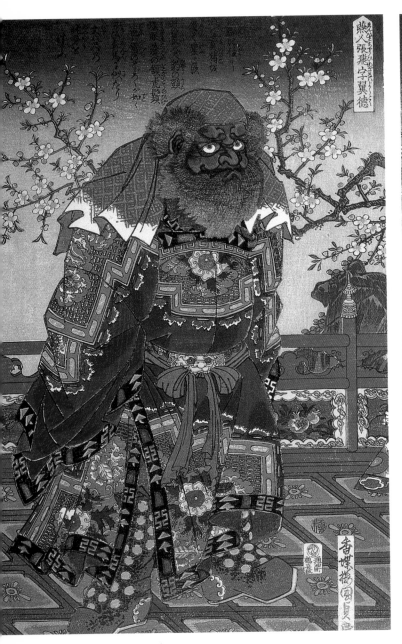
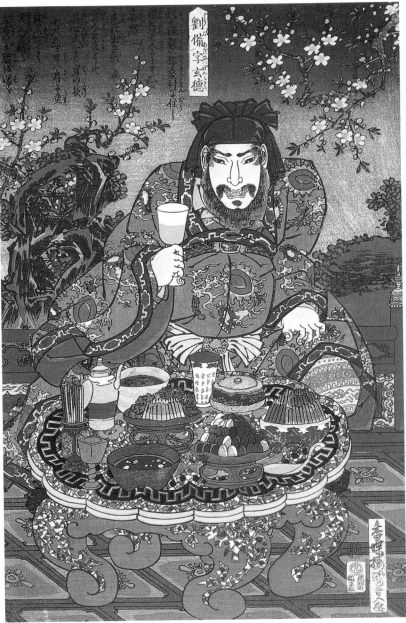

▲ **Utagawa Kunisada (1786-1864)**

The Pledge of Loyalty in the Peach Orchard

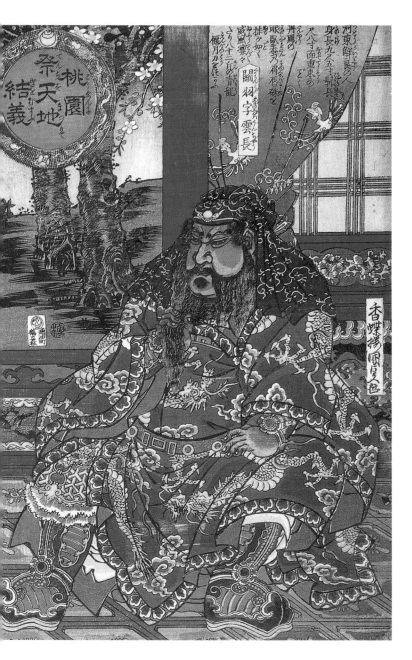

includes the name of each relay station and records the people he met along the way—often humorously—along with the customs of each region. The lyric beauty of the series is enhanced by the change in the weather and season as the series progresses. It brought him huge success.

He followed up with series of prints of famous places and, in the late 1830s, "Kisokaido Rokujukyu-tsugi No Uchi" (Sixty-nine Stations on the Kiso Highway). His pupils included his son-in-law Hiroshige II (1829-1869), who completed Hiroshige's "Meisho Edo Hyakkei" (One Hundred Views of Famous Places in Edo) after Hiroshige's death, and Hiroshige III (1843-94), who took the name when Hiroshige II's marriage broke up.

Meanwhile, the older traditions of *ukiyo-e* were being maintained by Utagawa Kunisada (1786-1864), a pupil of Utagawa Toyokuni. Kunisada produced the innovative "bijin-ga Imafu Kesho Kagami" (Mirror Modern Women), which placed mirrors in the center of the print with women's faces reflected in them. He also produced actor pictures and contined to keep up the tradition of erotica with his illustrations for *Nisa Murasaki Inaka Genji* (The Second Tale of Genji), which satirized the polygamous love lives of the rulers in Edo Castle.

After Utagawa Toyokuni's death, both Toyoshige and Kunisada took the name Toyokuni II, which made things very confusing. So Toyoshige was known as Hongo Toyokuni and Kunisada as Kameido Toyokuni from the areas where they lived. Things became even more complicated when a pupil of Kunisada's, Kinisada II, started signing himself variously Kunisada, Kunisada III, and Toyokuni III. There was, of course, another Kunisada III. He was a pupil of Kunisada II.

Kunisada's principal adversary was Utagawa Kuniyoshi (1797-1861). Their rivalry eventually split the Utagawa school in two. Under Toyokuni's leadership, there was intense rivalry among the students and Kuniyoshi seized his chance for fame by illustrating Suikoden, a long and heroic Chinese novel, where he developed new ways to depict masculine virility.

He also made advances in landscapes and *bijin-ga,* giving them a new realism by attempting to fuse Japanese tradition with the art of the West. In later life, he even studied photography—previously unheard of among the artists of the *ukiyo-e.*

Despite the dominance of Hokusai and the Utagawa school, a new *ukiyo-e* school was started by the son of Kano painter Kikukawa Eiji,

Kikukawa Eizan (1787-1867) who, before entering the artistic world of *ukiyo-e,* had made a living by making artificial flowers. He specialized in *bijin-ga,* in a long vertical format.

His most famous pupil was Keisai Eisen (1790-1848), well-known in Japan for his pictures of voluptuous, coquettish women and also for his erotica. In the West, he is best remembered for a series of landscapes which he had produced with Hiroshige. He was also the author of *Zorku-ukiyo-e-ruiko*, a history of *ukiyo-e*.

In 1868, the Edo shogunate fell and the Emperor Meiji was restored. The following year the Suez Canal was opened, shortening the journey from the West. The trickle of new ideas and objects had become a flood and the traditional world of the *ukiyo-e* seemed increasingly irrelevant. However, there were still no newspapers in Japan and prints continued to be the quickest means of communication.

One eccentric who stuck to the old ways was Toyohara Kunichika (1835-1900). He concentrated on *kabuki-e* and *bijin-ga*. His interest in women was more than professional. He was married forty times and changed addresses 83 times!

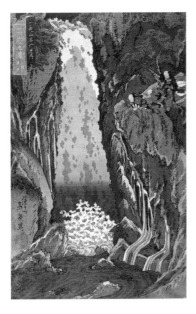

◄ **Keisai Eisen (1790-1848)**
The Kegon Falls in Nikko (c. 1835)

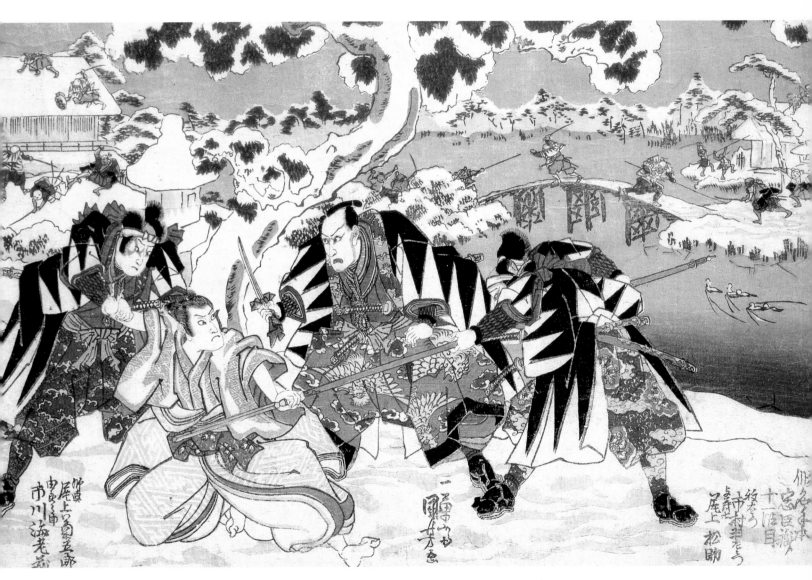

▲ **Utagawa Kuniyoshi (1797-1861)**

Scene from Act II of the Kabuki play *Chushingura* – The 47 Heroes Attack Moronao's Castle

Kunichika's pupil Yoshu Chikanobu (1838-1912), moving with the times, abandoned actors for prints of royalty and aristocrats in European clothes.

Tsukioka Yoshitoshi (1839-1892) brought new sensibility to the print. He was a pupil of Kuniyoshi and found himself in competition with Ochial Yoshiiku (1833-1904), an older pupil. Yet the two of them collaborated on a series of prints called "Eimai Nijuhasshu Ku" (Twenty-eight Stories of Violence). They depicted murder scenes and, to make the blood realistic, had a shiny, sticky animal glue—*nikawa*—mixed with the red paint.

They continued working on violent, grotesque and erotic themes. Then Yoshiiku began a *nishiki-e* newspaper. Yoshitoshi began working for a rival. At the start of the Meiji period, he produced a series of *bijin-ga*, but in later life, he looked to the past. He produced prints depicting legends and folklore, and a series called "Tsuki Hyaushi" (One Hundred Moonlit Historical Scenes). Then after a series called "Skinkei Sanjuroku Kaisen" (Thirty-six New Ghost Stories) he went insane and died.

Hiroshige III was active at this time. A pupil of Hiroshige, he was called Shigemasa; after Hiroshige II divorced Hiroshige's daughter, he married her and took the name. He is remembered as Hiroshige III, but called himself Hiroshige II. Meanwhile, Hiroshige II reverted to his name Shigenobu, but sometimes worked under the name Ryusho. Hiroshige III used *ukiyo-e* techniques to depict steam trains and Western architecture, in the process losing the poetic lyricism of his teacher and namesake.

The *ukiyo-e* tradition came to an end with Kobayashi Kiyochika (1847-1915). Samurai by birth, at the fall of the shogunate he was penniless and homeless. He studied under English painter Charles Wirgman, who lived in Yokohama, and was influenced by Western lithography and photography. Though he depicted traditional landscapes and weather, his output was Westernized. He was good at depicting gaslight and its reflection on water.

In 1881, the Meiji government's attempt to accede to the West caused a backlash—Kiyochika turned to tradition. His student, Inoue Yasuji (1884-1889), produced landscapes to rival his teachers, but died young. Ogura Ryuson was influenced by Kiyochika, and his landscapes appeared in two versions, one traditional and one varnished, aping Western oil paintings.

However, Kiyochika was the last great artist of the *nishiki-e* technique. With the end of the Meiji period in 1912, Japan was modernized. No more *ukiyoi-e* artists were trained and those remaining grew old and died.

▶ **Tsukioka Yoshitoshi (1839-1892)**
Meditation by Moonlight

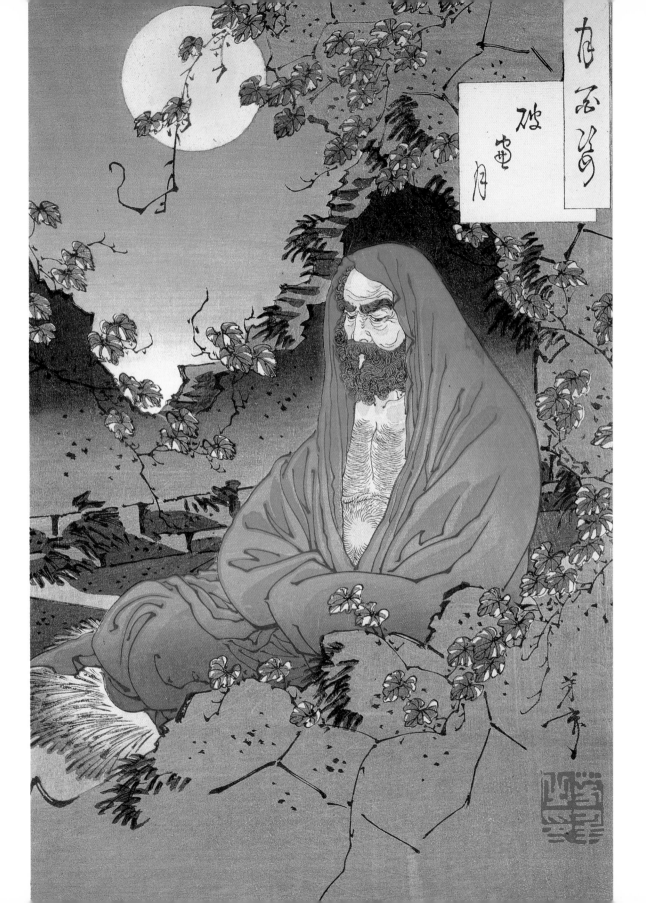

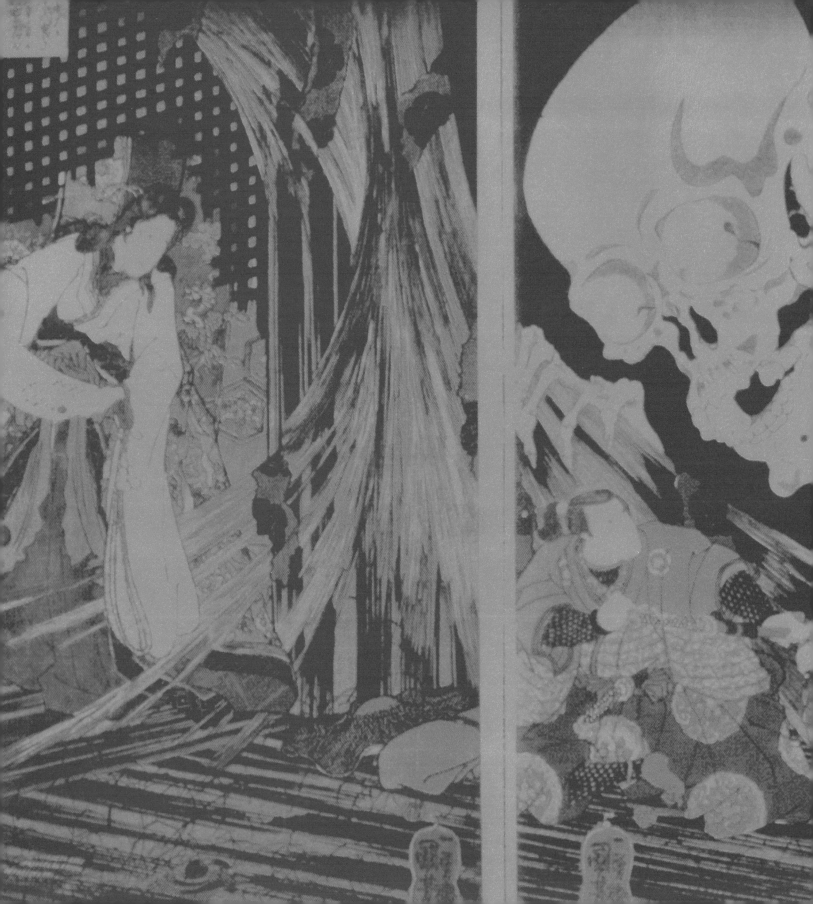

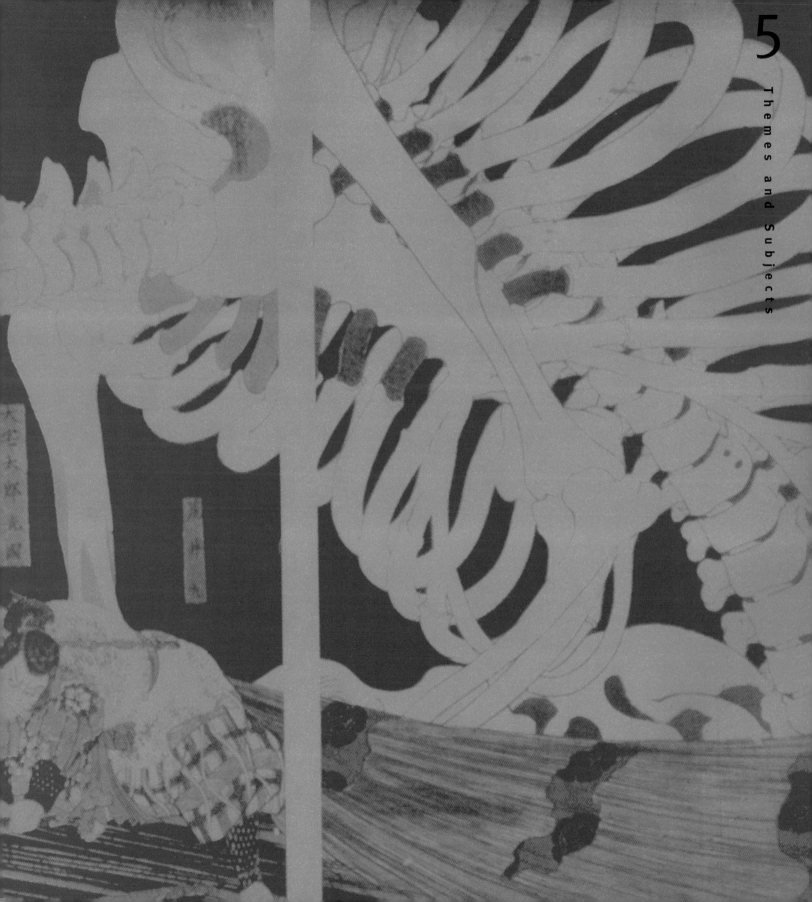

In Japan, marriages were arranged and there was little outlet for romantic adventure. In fact, there was little outlet for adventure at all. From the beginning of the seventeenth century, the country was (once again) under the firm grip of a military dictatorship which lasted almost three centuries, so there was little room for political change. After 1630, foreign travel became a crime punishable by death. A strict class system curtailed social mobility. All that was left was pleasure.

Japanese men found their outlet in the licensed pleasure quarters that were to be found in every city. This was the home of the courtesan and the *Kabuki*—and principal inspiration of the *ukiyo-e*. The most famous of these floating worlds was the Yoshiwara in Edo. From a shabby beginning, it grew to a mini-city, with its own parks, shops, restaurants, and gardens. According to the census of 1869, there were 3,289 courtesans working in 153 "green houses" or brothels. But there were also 394 teahouses.

The Yoshiwara was established in 1618. Until then there had been brothels all over the city and the Shogun was getting concerned about the disruptive elements they attracted. So shrewd brothel owners persuaded the Shogun to allow them to them build a licensed pleasure quarter, where prostitution could be kept in check and clients kept under surveillance. One of the rules was to be that no man could stay there for more than twenty-four hours at a stretch, so that even the idle would be forced back to work or any other duties.

The quarter was established on a reedy swamp called Moor of Rushes or Yoshiwara. After the great fire of Meireki, which destroyed half the city in 1657, the New Yoshiwara was built near the Asakusa Temple, where it remained until it was closed down in 1958.

A large body of literature soon celebrated the denizens of the floating world. These people were considered to be pariahs and social parasites by the feudal government, but at least two-thirds of the art in the seventeenth and eighteenth centuries found its subject matter in the *ukiyo*. It was only in the nineteenth century, when *ukiyo-e* was dying out because of the lack of new subjects and themes, that Hokusai and Hiroshige revived it with their fresh approach to landscape.

Ukiyo-e depicted the strict hierarchy in the "green houses" of Yoshiwara. The girls were either bought from poor families, often after a catastrophe such as an earthquake or a famine, or they were sold into

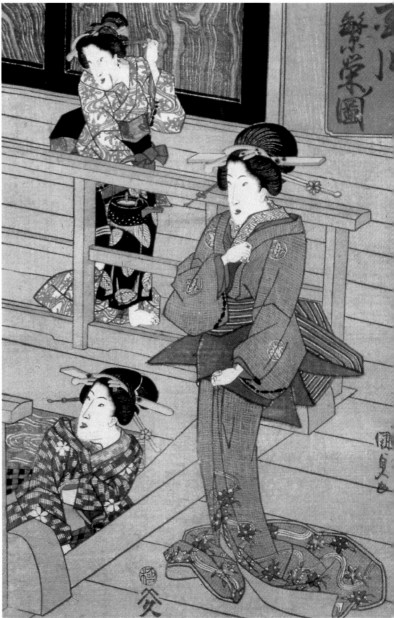

▲ **Utagawa Kunisada (1786-1864)**

The Teahouse at Edo (c.1827)

prostitution by noble families because of some disgrace they had brought on themselves or their ancestral home. Once they were behind the walls of the Yoshiwara, few ever left. The only possible escape for a girl was to have a rich man fall in love with her. He could then buy her freedom. But brothel owners kept meticulous records on how much they had spent on the training and upkeep of each courtesan. They came expensive.

When a girl first entered the *Omon* or Entrance Gate of a quarter, she was given a new name. Then, as a *kamuro*, she would be assigned as a maid to a courtesan. If the girl was beautiful, she would be trained in music, poetry, painting, flower arranging, and the tea ceremony. The ugly ones had to fend for themselves.

At the age of thirteen or fourteen, a *kamuro* would become a *shinzo*, meaning "newly constructed one." After five days of celebration, during which she would be adorned and pampered and paraded through the streets, she would be taught the erotic arts. Then she would soon go to work like the other prostitutes.

If she was exceptionally beautiful and gifted, she would rise to the rank of *tayu,* and command a formidable price. She would wear the richest of kimonos, carry herself with the grace of a princess and be waited on hand and foot by two *kamuros* of her own.

At the age of twenty-seven though, a courtesan's career would be over. If she was clever enough, she would move into brothel management. If not, she would wander the Yoshiwara with her bedroll, as a low street prostitute soliciting any client she could find.

In the *ukiyo,* money ruled, but a courtesan did not have to entertain any man who came along. To maintain their reputation, the top courtesans had to be selective. Any man who attempted to force himself on a woman against her wishes was derided as a *yabo* and became the laughingstock of the whole quarter.

The ceremonial courtship of a courtesan was often depicted. A man would have to visit a *tayu* three times—paying for food and entertainment on each occasion—before she would extend her favors to him.

The private lives of the courtesans was shown too. The women were variously depicted showing off a new dress to a companion, adorning themselves in the mirror, rehearsing a new song, hanging out the washing in the morning, writing or reading their love letters, playing battledore (an

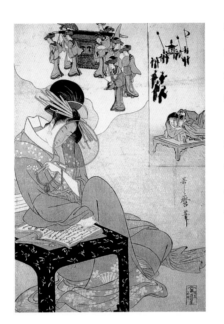

▲ **Kitagawa Utamaro (1753-1806)**

A Courtesan Dreaming of Her Wedding

◄ **Kitagawa Tsukimaro (active 1800-1820)**

A woman, possibly a courtesan, in headdress and kimono (c. 1800)

early form of badminton), or toying with a yo-yo. They can be seen in the gardens, admiring the flowering cherry trees, walking with their lovers to the teahouse or *Kabuki,* or on the pleasure boats of the Sumida River, a favorite spot for amorous adventures.

There was a huge demand for instructional and often pornographic *shunga* prints. Where better to find models than the floating world? To Western eyes, these seem crude and unnecessarily detailed. But the Japanese would give "pillow books" containing the most explicit prints to a young bride so that she could better satisfy her husband—and herself.

People also wanted straightforward portraits of the famous courtesans of the day. They were, however, rarely painted nude. Even in the mildly erotic, after-bath prints, the body is usually partly shrouded by a dressing gown or a towel. The ideal of Japanese beauty usually concentrated on the face, the hair, and the dress.

Bijin-ga, or "beauty pictures," were principally fashion prints, showing the very latest clothes and hairstyles. While the faces are often flat and featureless, *ukiyo-e* artists paid a great deal of attention to every detail of the hair. Fashions in clothes and hairstyles came and went so quickly, it is often possible to date a print accurately from these features alone.

There were fashions and preferences in female beauty, too. The Primitives—the earlier *ukiyo-e* artists who made the monochrome and hand-colored prints—preferred tall, majestic women. Harunobu preferred his women petite. Utamaro, Eishi and Kiyonaga liked them tall and slim, while Eisen's women were always voluptuous.

Gallants visiting the courtesans also present the artist with a great deal of material. There were rites and rituals here too. When visiting the Yoshiwara, a man would first visit the *hikite-jaya,* or house of introduction. There he would be helped in his choice of brothel and courtesan. The terms would be negotiated, and then a serving girl would escort him to the appropriate green house. She would wait on him during dinner and take care of him until he entered his sleeping chamber; and that was when the courtesan turned up.

Around 1750, the geisha was introduced. She was employed in order to entertain a man during dinner with singing, dancing, and conversation. The geisha was not actually a prostitute, and only the low-class geishas extended sexual favors to their customers.

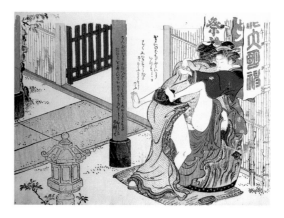

▲ **Torii Kiyonaga (1752-1815)**
An erotic color print

▶ **Kitagawa Utamaro (1753-1806)**
The Hour of the Monkey

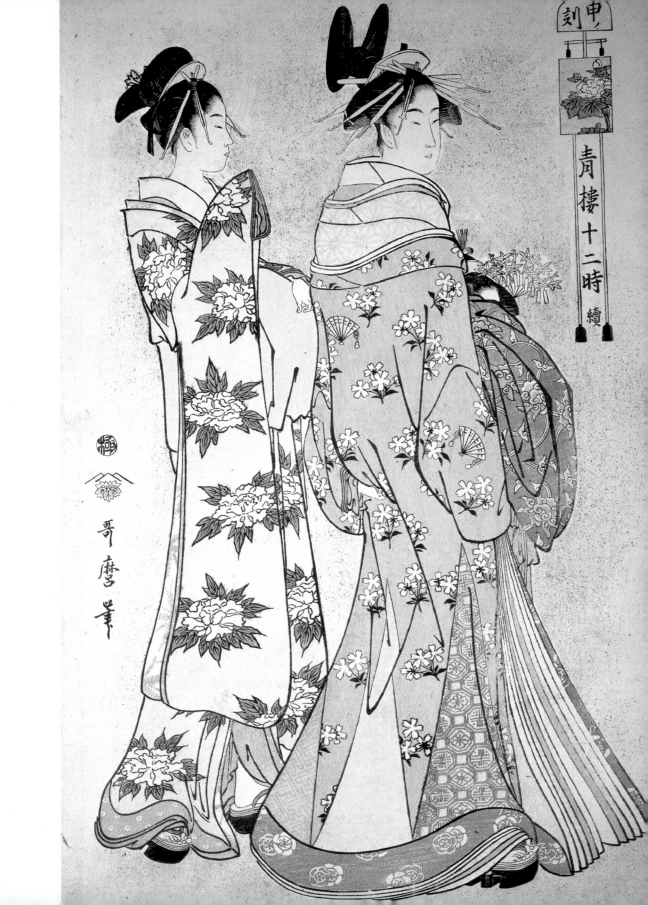

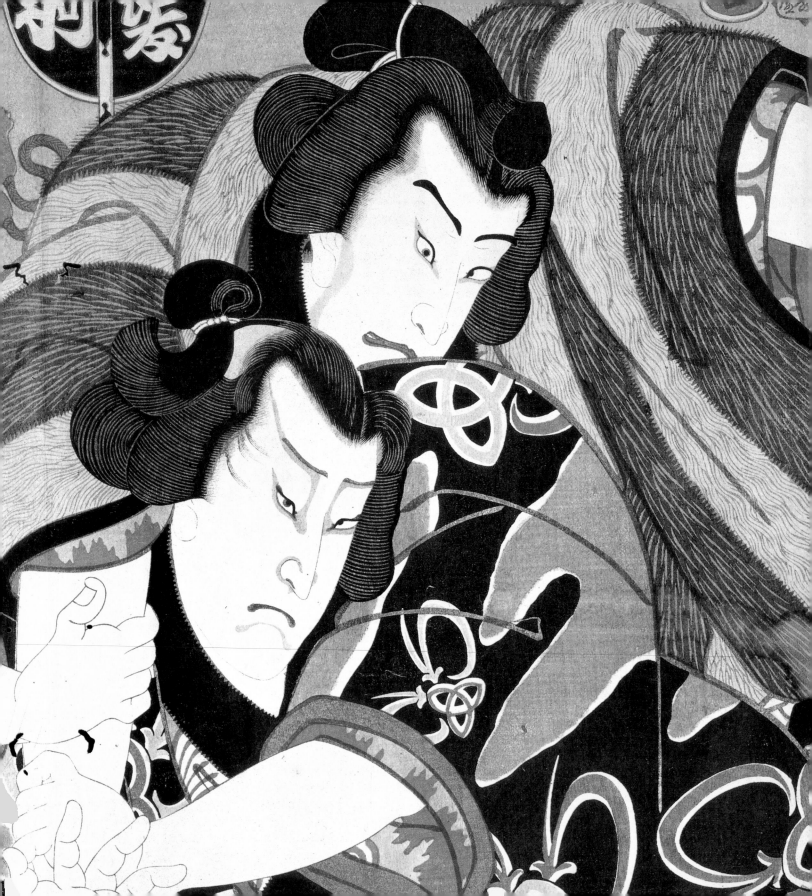

The everyday pleasures of Edo was a constant theme of the Japanese print. There were street festivals every month and *ukiyo-e* artists seized these as opportunities to depict firework displays, regattas on the river, processions, and pageantry.

Yet, the Yoshiwara was also the center of intellectual life. Under the repressive shogunate, it was one of the few places a man could think and talk freely. Along with writers and artists, even political activists sought sanctuary there. The talk of revolution gave the work of the *ukiyo-e* artists an interesting edge, and the great political underground which fomented the 1868 revolution was spawned there.

The *Kabuki* theater was seen as part of this floating world of pleasure. It originated in the seventeenth century and, stripping the classical *Noh* theater of its stiff brocades, it gave the actors a new freedom of movement in fashionable silks. Traditional dance and features of the already popular puppet theater were added. The result, to the Japanese eye, was to give the plays' poetry greater realism. But to Western eyes, the plays are full of violence and bathos. *Kabuki* is intensely melodramatic. It has all the grace and movement of ballet, but pauses occasionally in colorful tableaux. It is the perfect subject for art. The three great schools of *ukiyo-e*—the Torii, the Katasukawa, and the Utagawa—all make *kabuki-e* a mainstay.

Prints usually show a single actor in character. Otherwise two are shown, dramatically posed in a dynamic composition. Backgrounds are nonexistent, though sometimes some of the actor's props are included.

Katsukawa Shunsho was one of the greatest masters of the actor print. His figures are depicted in action against a lightly indicated backdrop. Ippitsusai Buncho was probably the master of the *onnagata*, the actors who took female parts in *Kabuki*. In his prints, it is difficult to distinguish them from real women.

But the great innovator was Sharaku, his caricatures were so savage that it was rumored that he had been murdered by an aggrieved actor when he disappeared from the world of *ukiyo-e* in 1795.

The Japanese have always shown a great reverence for nature. They would hold parties to watch the sky and compose poetry at New Moon. Or they would gather together to view a cherry tree that had recently come into blossom, admire the red autumn leaves of the maple, or watch the first new fall of winter snow.

▲ **Utagawa Kunisada (1786-1864)**
Two Main Characters from a Kabuki Play

◀ **Utagawa Kunisada**
The Actor Nakamura Utaemon in a Scene from a Kabuki Play

Themes and Subjects

This love of nature produced *Kacho-e*—or bird-and-flower pictures which have no real equivalent in Western art. They were originally the province of painters of the classic Japanese Kano or Chinese schools, whose aesthetic was usually spurned by the artists of the *ukiyo*. However, from Kiyomasu and Shigenaga right through to Koryusai, Utamaro, Hokusai, and Hiroshige, Japanese print artists cannot resist handling their natural history pictures with all the sincerity of their classical counterparts.

Landscape was also a staple of the classical school—and shunned by the early *ukiyo-e* artists who tried to restrict their art to the closed world of the Yoshiwara. However, landscape kept creeping to the background. Toyoharu, who first studied as a Kano painter, was the first to introduce pure landscape. This may have been because he was influenced by Western art, producing *uki-e* and even landscapes with a bird's-eye view.

With Kiyonaga and Eishi, the background achieved more prominence, though they largely depicted townscapes. And Utamaro produced some pure landscapes in 1790. However, it is Hokusai and Hiroshige who made landscape the theme of *ukiyo-e's* last great flourishing.

The *ukiyo-e* artist's imagination also strayed out of the Yoshiwara to the world of history and legend. Few could resist depicting great acts of valor and chivalry. War—particularly the civil war between the Minamoto and Taira clans through the middle ages—and violence were also minor themes. The great master was Kuniyoshi, who produced triptychs showing some of the great battles.

However, many historical and mythical themes are handled tongue in cheek. *Ukiyo-e* artists liked to parody the work of Kano painters, with the women of Yoshiwara and their lovers substituted for classical figures. Arcane analogy is used to make courtesans suggest famous events and places. The six "jewel rivers" of Japan are regularly portrayed as beautiful, extravagant kimonos worn by women from the green houses.

The Genji Romance, a classic story set in the Imperial court of the tenth century, was depicted in prints, with the women of the Yoshiwara enacting famous scenes. *Seven Famous Scenes* in the life of the poetess Komachi was parodied by every major *ukiyo-e* artist. And parodies of the popular melodrama *The Forty-seven Ronin*—ronin were unemployed samurai— became so far-fetched that print artists had to include a small inset so the viewer would know which scene was being lampooned.

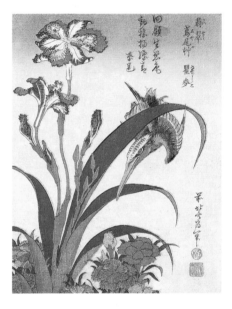

▲ **Katsushika Hokusai (1760-1849)**
Kingfisher, Irises, and Pinks (c. 1830)

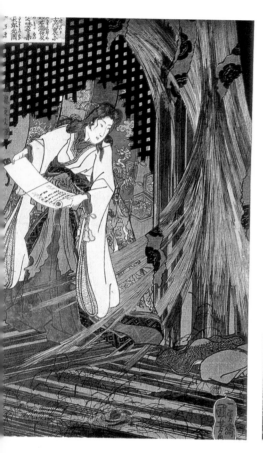
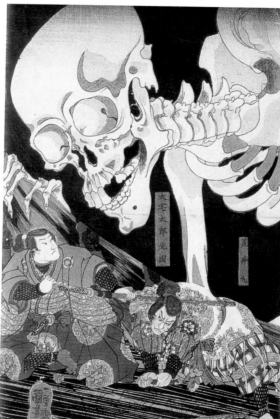

▲ **Utagawa Kuniyoshi (1797-1861)**

Mitsukini Defying the Skeleton Specter (c. 1845)

▶ **Utagawa Kuniyoshi**

(Overleaf) The Earth Spider Slain by the Hero Raiko's Retainers (c. 1838)

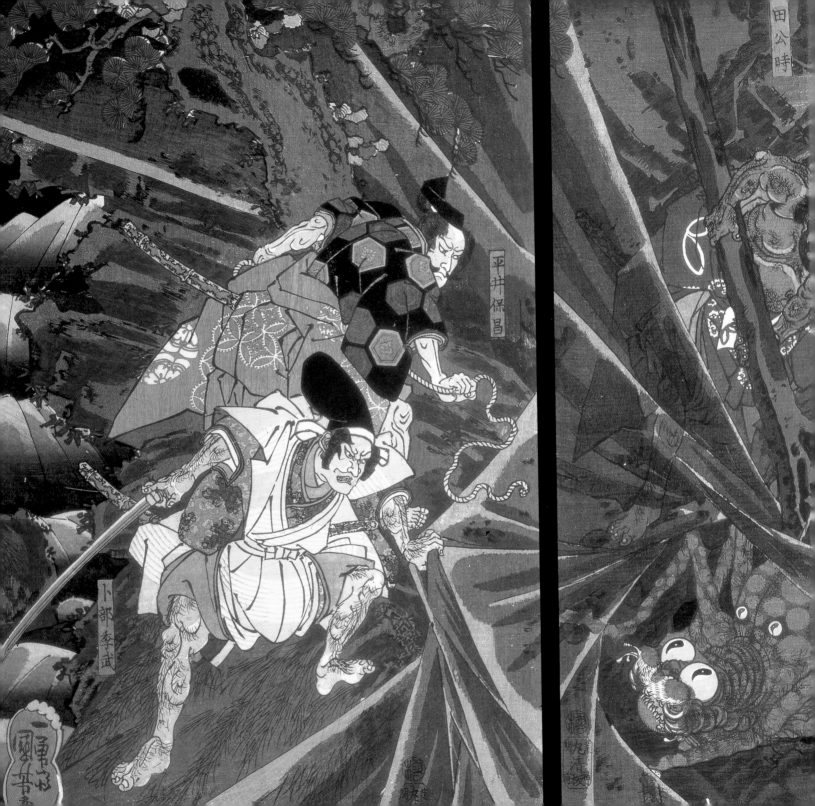

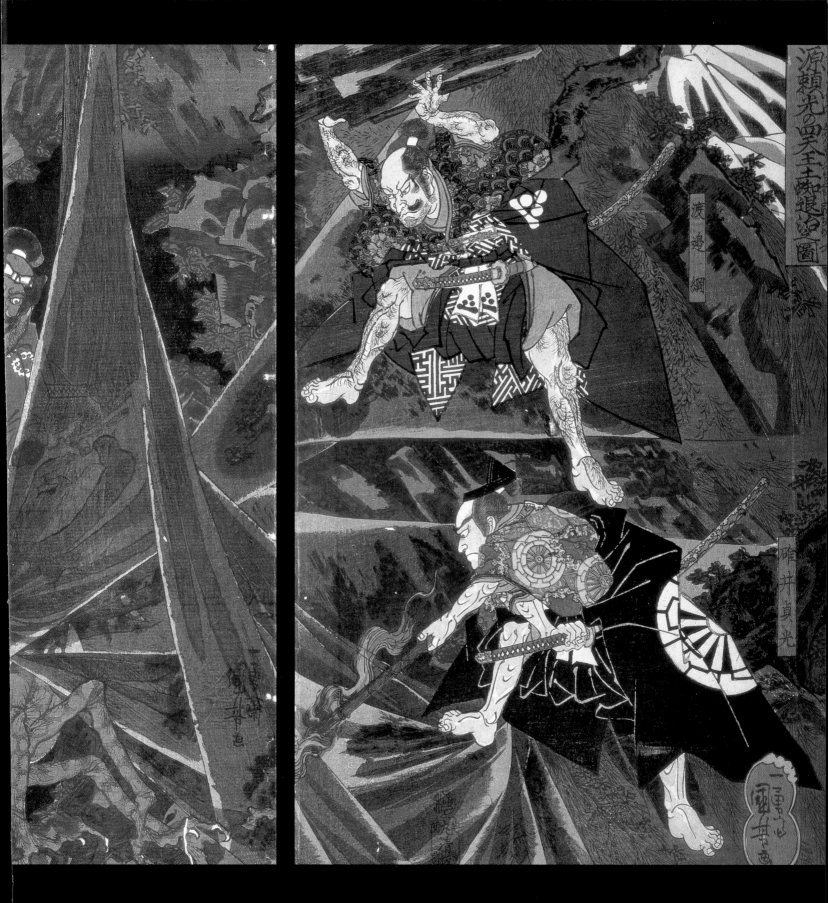

Until 1853, the world of the *ukiyo-e* was closed, like Japan itself was closed. Few in Japan saw any form of Western art and outside Japan the *nishiki-e* was unknown.

The myth grew up that the first prints reached the West as wrapping paper around delicate oriental china that was being exported to Europe. However, the man who started the fashion for Japanese art was the French engraver, Felix Bracquemond who came across a copy of Hokusai's *Manga*. He showed it to friends and artists. Soon a shop opened selling *objets d'art* from Japan, including prints.

Edouard Manet (1832-1883) was the first to be influenced. He picked up on the way everyday scenes were used as subject matter in Japanese prints and he decreased the perspective in his pictures Japanese-style. Instead of using the shading and modeling of the academic painters, he painted the flat blocks of color seen in Japanese prints. He also had access to the *Manga,* and when he painted Emile Zola's portrait, he included a Japanese screen and an actor print in the background.

Japanese prints also helped free Edgar Degas (1834-1917) from the restrictions of the academic subjects of the time. He picked as his major subject one of the great themes of the *ukiyo-e*—women at their toilette. His other major topic was ballerinas, surely the European equivalent of both the geisha and the *Kabuki*. Like Manet, he flattened his pictures, thereby losing depth in a very Japanese way.

The wrapping paper myth may have sprung up around Claude Monet (1840-1926). He first saw Japanese prints in *Le Havre* but, fourteen years later, he spotted some more in a china shop in Amsterdam. He offered to pay the full price for a vase, if the prints were thrown in.

"As you wish," replied the shopkeeper, "they are no good to me."

Monet's dining room was soon filled with Japanese prints and their influence in his work is clear. In his painting "Terrace at Sainte Adresse" (1866), he used flat blocks of color and painted waves by using short strokes of different colors, a method already perfected in Japan. And in "La Japonaise" (The Japanese Fan), painted in 1876, he demonstrates his fascination with all things Japanese.

The American artist James Whistler (1834-1903) was exposed to Japanese prints when he studied at Charles G. Gleyre's atelier in Paris. In "Caprice in Purple and Gold, No. 2—The Golden Screen," painted in 1871,

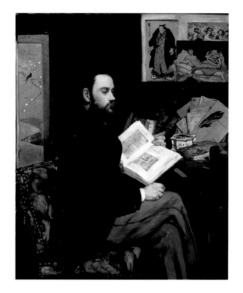

▲ **Edouard Manet (1832-1883)**
Portrait of Emile Zola (1868)

▶ **Claude Monet (1840-1926)**
The Japanese Fan (1876)

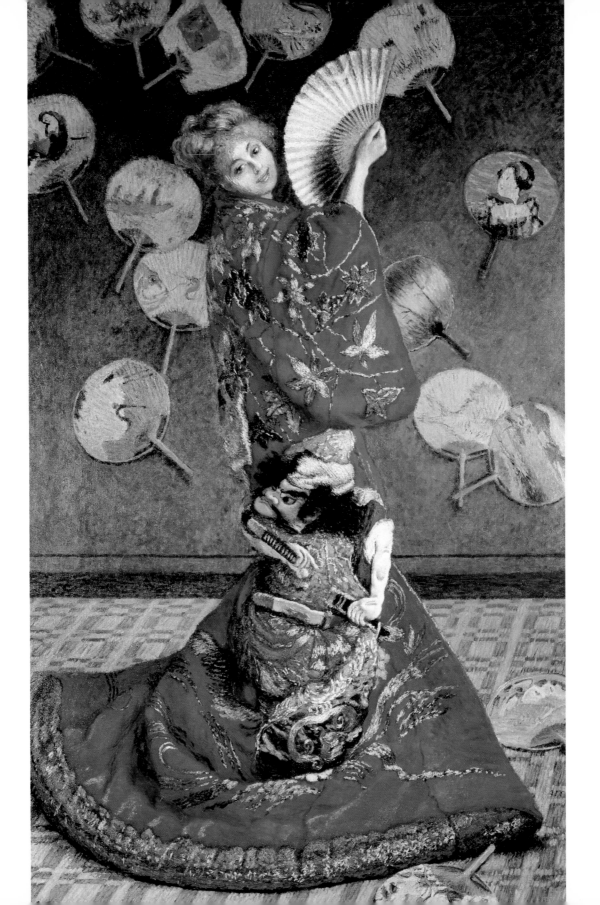

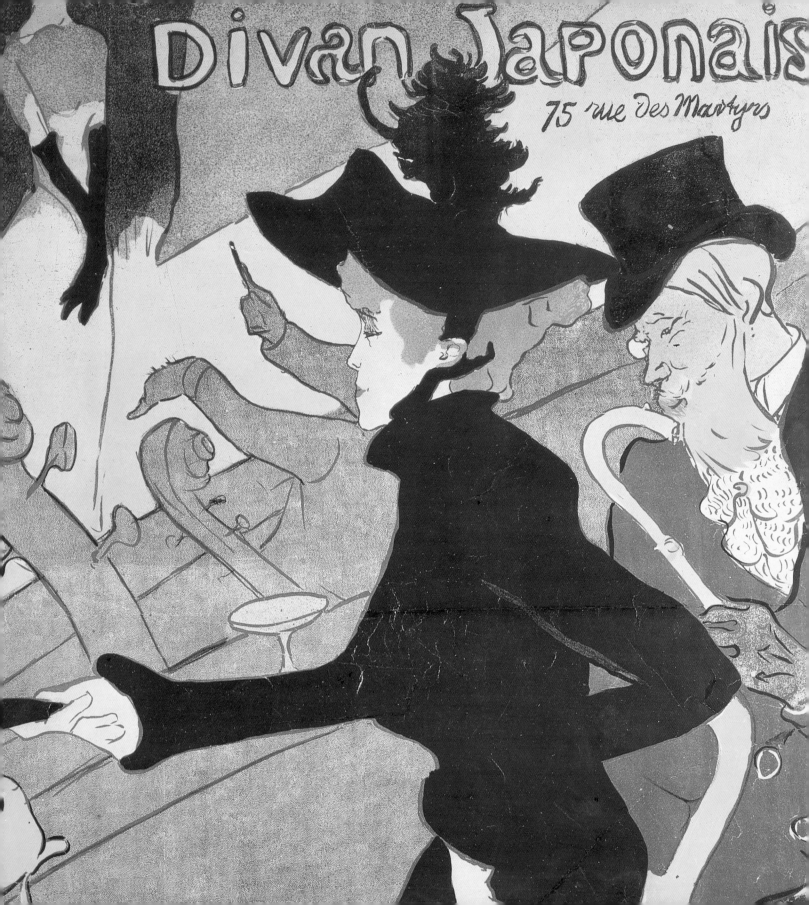

he used the flat elements of a *ukiyo-e* print. The model is wearing a kimono. She is surrounded by Japanese artifacts and the background is a Japanese screen. Even his famous "Portrait of the Artist's Mother," again painted in 1871, is composed of large flat areas of gray and black, with little or no perspective.

Henri Toulouse-Lautrec (1864-1901) was introduced to Japanese prints by Degas and became a collector. In his paintings, their influence can be seen in the lack of shading. Modeling is produced by line and contrast of light and dark areas.

The *nishika-e* influence is even more pronounced in his well-known lithographs. In these he uses flat areas of bold color, cut-off figures, expressionless faces, and caricature, all borrowed from Japanese prints.

Reacting against the Impressionists, artist Paul Gauguin (1848-1903) produced paintings of the South Seas that use flat blocks of color and banish perspective. His trees are stylized in a very Japanese way. And a Kuniyoshi print of three cats seems to have been the inspiration for his "Three Puppies," painted in 1888.

Gauguin's friend Vincent van Gogh (1853-1890) studied Hokusai's "Hundred Views of Mount Fuji" while he was learning to draw. In 1886, he painted "Japonaiserie: Trees in Bloom," after Hiroshige. "Japonaiserie: The Bridge in Rain," painted in 1887, is almost an exact copy of Hiroshige's "Sudden Shower at Ohashi." And "Japonaiserie: The Actor," 1888, is a copy of an actor print by Keisai Eisen.

In van Gogh's "Portrait of Pere Tanguy," 1887, the old shopkeeper is painted surrounded by Japanese prints. But all of van Gogh's later work, particularly the famous ones with all their flat surfaces, sharp lines, vivid colors, and lack of perspective, show the profound influence of Japanese prints—an influence he discusses in his letters to his brother Theo.

The flamboyance of Art Nouveau has been ascribed to in the influence of Japanese prints, and elements of *ukiyo-e* can be seen in Expressionism, Cubism, Futurism, Surrealism, and Abstractionism. In fact, it would be hard to find any area of modern painting or graphic art that does not owe some debt to the Japanese print.

Western art had little impact on *ukiyo-e* of the classical period 1658-1868 because so little was seen in Japan. However, Okumura Masanobu developed the *uki-e*, incorporating a Western sense of perspective and

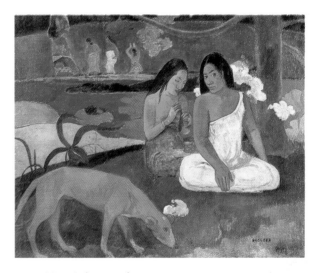

▲ **Paul Gauguin (1848-1903)**
Arearea (1892)

◄ **Henri Toulouse-Lautrec (1864-1901)**
Le Divan Japonais

Toyoharu seems to have been influenced by Western copperplates, even copying one by Antonio Visentini, as did Toyohuni's pupil Kunitora.

The Utagawa school seems to have been particularly open to influence from the West. Utagawa Kuniyoshi used Western influences for inspiration to add a new realism to *ukiyo-e*. And after Japan was opened, he even took an interest in photography. Hiroshige III depicted Western scenes and Kiyochika studied under an English artist.

Twentieth-century printmakers could hardly help but be influenced by the West. Goyo Hashiguchi (1880-1921) learnt Western-style painting under Kuroda Seiki. Although he had been compared to Utamaro and Hiroshige, his composition is quite clearly influenced by Gauguin. Like most modern *ukiyo-e* artists, Goyo worked in a very different way to the printmakers of the golden era. He did not just draw the design and leave the rest to the block-maker and printer. He oversaw the whole process.

Hasui Kawase (1883-1957) worked the same way. His prints used Western perspective and his "Bamboo Yard at Komagata Riverside" shows in its composition some influence from the Renaissance.

The prints of Kanae Yamamoto (1882-1946) are reminiscent of the paintings of Gauguin and van Gogh. He traveled widely in Europe as a youth and he often depicted Western subjects. Yamamoto cofounded a new school with Koshiro Onchi (1891-1955). It was Onchi who made the most significant impact with his abstract prints, although he was also a very accomplished portrait artist.

Gauguin's Post-Impressionism also had a great influence on Kiyosho Saito (born 1907). He was another painter turned wood-block artist. He became so well-known in America that, in 1967, he was commissioned to produce a wood-block print of Premier Eisaku Sato, which was used on the cover of *Time* magazine.

Saito is also influenced by Expressionism, particularly Edvard Munch who, he admits, is his favorite artist. In fact, practically every Western school of art now finds its reflection in contemporary Japanese prints. The influence of Gauguin, van Gogh, Picasso, Klee, Miro, and Kandinsky – the Western artists most clearly influenced by Japanese prints in the first place —is particularly striking. Which means that the art of the Japanese print has now come full circle.

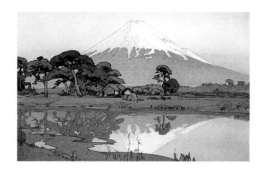

▲ **Hiroshi Yoshida (1876-1950)**
The Lake at Suzakawa

▶ **Goyo Hashiguchi (1880-1921)**
Woman After the Bath (1920)

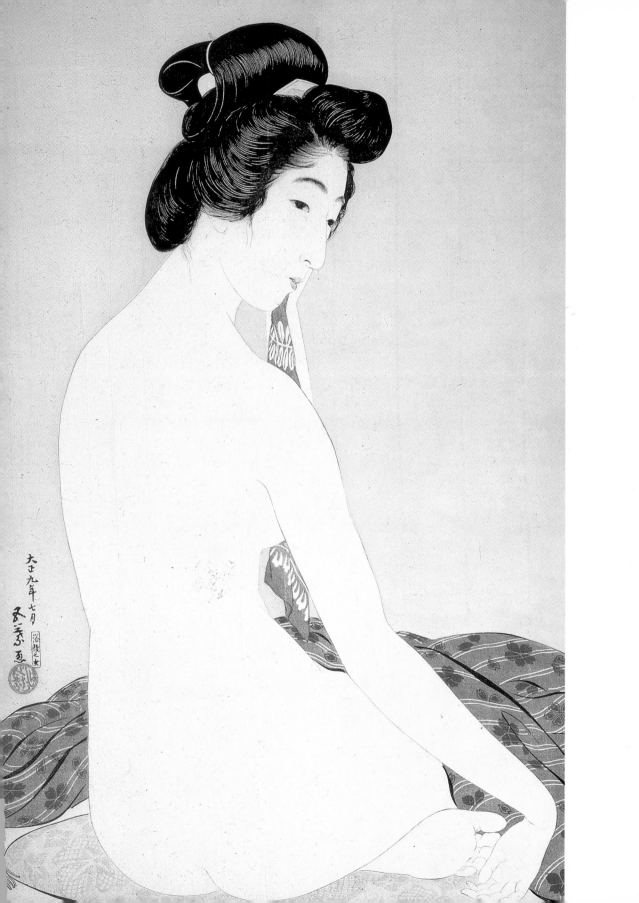

Acknowledgments

Front jacket, Flap and Spine: Bridgeman Art Library/Christie's Images.
Back jacket: Bridgeman Art Library/British Library.

AKG London 2/3,/Erich Lessing 83; **Bridgeman Art Library**/Art Institute of Chicago 16,
11, 12,/British Library 20, 21, 28, 32, 33, 41, 42, 45, 46, 47, 50, 52/53, 56, 57 right,
57 left, 70, 79, 81,/British Museum 12/13, 14/15, 17, 18, 19, 40, 43,/Chester Beatty
Library & Gallery of Oriental Art, Dublin 55, 95,/Christie's Images 60,/Fitzwilliam
Museum, University of Cambridge 8, 62/63, 64,/Lauros-Giraudon 91,/Louvre 93,
/Maidstone Museum & Art Gallery, Kent 6/7, 11, 38/39, 71,/Musee d'Orsay, Paris 90,
/Private Collection 4/5, 10, 24/25, 26, 29, 30, 31, 37 left, 37 centre and left, 44, 51, 58,
59, 65, 66/67, 68/69, 72, 73, 82, 86/87, 94, 96,/Victoria & Albert Museum 22/23, 23,
27, 34, 48, 49, 74/75, 76/77, 78, 80, 84, 85, 88/89, 92.